Eerie GEORGIA

CHILLING TALES FROM THE MOUNTAINS TO THE SEA

Jim Miles

THE
History
PRESS

Published by The History Press
Charleston, SC
www.historypress.com

Copyright © 2018 by Jim Miles
All rights reserved

First published 2018

Manufactured in the United States

ISBN 9781467140218

Library of Congress Control Number: 2018942446

To my Adams family:
Miss Betty, Mr. Aaron and Angie, Danny, Pam and Tim.

CONTENTS

INTRODUCTION

I grew up in the great southern city of Mobile, Alabama, where as a child I gained a great appreciation for history and the paranormal. I moved to Georgia with my family fifty-three years ago and have spent more than a half century intensely studying the history and strangeness of my adopted state and gathering information about Georgia heritage, its curiously talented people, unique places and the many odd things that have occurred and continue to happen. My fascination with all things strange in Georgia continues unabated, hence this latest volume in the annals of Peach State weirdness.

An epidemic of flaming crosses suddenly appeared in church windows, telephone calls from beyond have been received and voodoo spells, past and present, occur along the coast. There are strange weather phenomena, such as storms of stones, eggs, alligators, turtles and frogs. Houses unaccountably rap and shake, and the sounds of phantom gravediggers are heard in cemeteries.

All types of strange creatures have popped up across Georgia, including giant sea monsters off the coast, a violent, vindictive Mothman, aggressive werewolves, banshees announcing the deaths of family members in Milledgeville, pterodactyls witnessed by half a dozen people, a hideous duckgator with wings, a flock of ghosts/aliens/fairies that flitted around Coweta County and prowling ghost and demon dogs.

Among our strange citizens are an actual zombie, entranced people who cannot be harmed by fire, mad gassers who terrorized several communities,

a U.S. senator who doubted the Warren Commission's findings about JFK's death and a perpetrator of grand theft sleepwalking.

Ghosts inhabit fine establishments, including the Blue Willow Inn restaurant, the Springer Opera House and the grand lodgings of the Windsor Hotel; even a Waffle House has ghosts. A long-dead Confederate sentry walks his beat outside an Atlanta TV station. The spirit of Elvis actually appeared in a dream to lead a father to his missing son.

A surprising number of Georgians have reported encounters with alien beings, rarely with a benevolent outcome. Connie endured a lifetime of abductions and unknowingly produced sickly, hybrid children. Space invaders run amok through suburbs and forests, and a Georgia woman comforted and fed a sickly alien. A telepathic genie projected calm to one man, and a being with a jetpack flew outside the seventeenth floor of an Atlanta hotel. An alien abductor doctor offered important medical advice to one "patient."

For those interested in the continuing UFO saga, there are a reported crash in Columbus and multiple sightings dating from the nineteenth century. A spectacular encounter with giant boomerangs occurred near Claxton, and a teenage couple was buzzed in a Waycross area swamp. One mother in Rutledge was pursued by a UFO that left burns on her face, and an entire community gathered for nights of UFO watching. Proper investigation turned one UFO into an IFO, an identified flying object.

Jimmy Carter accompanied his father to consult a psychic about a missing dog, and a North Georgia women hired a seer to help locate the culprit who pignapped and ate her pet porker. One dowser intrigued a professional archaeologist with his ability to locate ancient bones, and a dying woman left her body to visit her mother. A Georgia ranch was repeatedly raided by cattle mutilators.

Ancient Georgia remains as strange as the contemporary state. There was a mud volcano thought to be possessed by demons that were restrained by human sacrifices and a unique stone temple, as well as a ceremonial complex where God once trod paths with humans. Artifacts prove the presence of transatlantic voyages long before Columbus, and ancient carvings may have been created by stoned shamans.

Georgia's strangeness not only continues, it seems to intensify and morph into even odder events that are reported with increasing frequency as awareness of these events expands. While the quest for Georgia weirdness continues, an understanding of these phenomena remains elusive. Perhaps the best we can do is chronicle it and enjoy sharing the stories.

STRANGE PHENOMENA

MIRACLES

Flaming Window Crosses

Mysterious phenomena often come in waves, persist for a short time and move on, often to never return. This is just a characteristic of strange events.

In 1971 and 1972, images of glowing crosses began appearing in church windows in Los Angeles and Florida before arriving in Brunswick, Georgia, where the first appearance was not in a church, but rather a window of the Glynn-Brunswick Memorial Hospital before expanding to houses of worship at Mount Olive Baptist, Church of God, Seventh-day Adventist and St. Andrew's Methodist.

A witness within the Seventh-day Adventist church saw "a bright cross several miles in length and width." At St. Andrew's, a scroll appeared in a window. After sundown, dark words became visible on the scroll, revealing it to be a copy of the Ten Commandants.

Crowds of curiosity seekers flocked to the churches. Brunswick city officials—fearful of traffic congestion and possible injuries to pedestrians and motorists—took the debunkers role by parroting the standard explanation of light refraction. The view of the faithful was summed up by Shiloh Baptist Church minister Reverend E.C. Gilman: "For those with faith, no explanation is needed. For those without faith, no explanation is possible."

In the '70s, images of a glowing cross began mysteriously appearing in church windows across the country, including Brunswick, Georgia. *Illustration by Sarah Haynes.*

In October and November 1972, flaming crosses spread to St. Paul's African Methodist and First African Methodist Church in Kingsland, Savannah's Union Baptist Church and the Darien home of Mr. and Mrs. George C. Hall, as well as the Bronx, New York, where it was seen as a sign of the Second Coming, and additional sites in Florida.

The church windows in Georgia were largely supplied by the Brunswick Glass Company, which noted that the phenomenon could be explained by "finely obscure," an effect of light on internal vertical and horizontal lines in the glass. However, such glass had been around for a considerable time and no flaming crosses were reported until this two-year period, and only rarely afterward, and also not in Jewish temples with the same glass—only in fundamentalist evangelical sanctuaries.

Many witnesses claimed a renewal of their faith, and in each location in the Deep South, which still held vestiges of segregation and racial tensions, black and white citizens freely mingled to marvel at the religious phenomenon. There were several reports of healing, including Robert Mill, who suffered from a crippled spine. After viewing a glowing cross in a church window, he leaped to his feet and ran around the church, waving his cane in the air.

This phenomenon was described by David Techter in the June 1972 issue of *FATE* magazine.

What Caused the Shaking House in Dodge County?

Southeastern Georgia was opened to development with the completion of the Macon & Brunswick Railroad in 1870. The primary resource of the area was pine trees. A county created by the Georgia General Assembly was named Dodge, and the county seat was dubbed Eastman, for William Eastman Dodge, a New York timber baron.

Nearly fourteen years after the great poltergeist mystery at Surrency and fifty miles to the northwest, a similar mystery evolved, as related in the *Eastman Times* and reprinted in the *Savannah Morning News* of September 3, 1886.

In the Pond District of Dodge County, there was a simple one-room cabin made of hewn wood by Woot Parker that, according to the paper, "is attracting a great deal of attention just now…it has caused considerable excitement" in the area. It had started shaking "three weeks earlier, with no cause." According to the paper, "the building commenced to shake, and the occupants rushed out, thinking it was going to fall, but it didn't. It continued to shake however, for about two hours. The cups on the table were turned over, the clock on the mantel was stopped, and in fact nearly everything in the house was thrown into general disorder."

After the initial incident, the house continued to shake about every two hours. The Parkers, baffled by the events, told their neighbors, but no one believed them. Woot finally persuaded several respected citizens to visit the house and witness the phenomenon firsthand. Four arrived—Jesse Brown, Dan Craver, J.C. Pearson and J.C. Hilliard—and "all state positively that it does [shake], and that there is not the slightest perceptible cause for it." After word of the mystery got around, "crowds are visiting the house," and each "who have been there say that the house does shake."

A one-room cabin in Dodge County caused a stir when it began to shake for hours with no apparent cause. *Illustration by Sarah Haynes.*

FREAKISH STORMS:
FOUR TORNADOES AND A WATER SPROUT

A tornado struck a Covington outhouse in 1925, surprising the occupant inside. *Illustration by Sarah Haynes.*

I bought a copy of *Freaks of the Storm, from Flying Cows to Stealing Thunder: The World's Strangest True Weather Stories* by Randy Cerveny. I immediately turned to the index and found five entries for Georgia, which I summarize here.

Two tornados devastated Gainesville in 1903 and 1906. According to a meteorologist who spoke with Cerveny, a man lost his wife during the first tornado. He remarried, only to have his second wife killed in the next tornado three years later.

A Georgia newspaper report in 1925 reported that Andrew Tillman of Covington was found following a tornado under the ruins of his outhouse. While that fact is strange and amusing enough, that was not the unique aspect of this case. Doctors found that several pieces of bone had penetrated the victim's brain. Surgeons extracted the bones and a "tablespoon" of the victim's brain. Most amazing was the claim that the patient seemed to recover normally.

According to the *Literary Digest*, in 1932 a massive F4 tornado tore through Georgia, throwing a farmer violently into a barbed wire fence. When found, he was spread-eagled on the fence, much like an ancient Roman crucifixion. The unfortunate fellow was rushed to a hospital but died of his storm-inflicted wounds.

In 1849, *Scientific American* related the story of a violent cloudburst that fell on Alpine, a community near the Alabama border in Chattooga County. "A Water Spout, of immense size" fell on the region and made "an impression in the earth thirty feet deep and forty or fifty feet wide," the report stated. The water spout destroyed a number of huge trees and dislodged massive stones from a hillside.

Nuggets: Odd Stories from Across Georgia through the Years

This odd story was found in *I See by the Papers, 1899–1946,* complied by the Bullock County Historical Society. During the last week of June 1917, two men fell into the Ogeechee River near Ivanhoe during a picnic. They drowned, and the bodies failed to surface. Searchers threw dynamite into the river in "efforts to raise the body," but the dead never arose. However, each blast brought "large quantities of fish," it was noted, and "the picnic continued with little interruption." The fiddlers never ceased playing "and the frying of dynamited fish was a pleasant feature."

Macon County: A Good Hand Is Hard to Find

In *History of Macon County,* we learn that Abner Watkins was one of Oglethorpe's first settlers when the community was established in 1849. A prominent citizen, Watkins owned considerable land and many slaves, and "it was said that at times he was a cruel master." He died just before the Civil War started in 1861, and his funeral "was the largest the county had ever seen owing to his prominence and wealth." Hundreds attended his burial at the city cemetery in Oglethorpe.

On the following day, passersby noted that the coffin had been excavated and opened. An inspection revealed that the "body was exactly as interred except that his right hand was missing. It had been amputated as cleverly as though it had been cut by a skilled surgeon." Some believed it was an act of revenge by abused slaves, while others thought "someone wanted to use his 'good right hand' in signing a document," a unique belief at the time.

An Ill Wind

A terrible storm swept through Georgia in early July 1877, as described by the *Savannah Morning News* of July 12. A newspaper in Calhoun noted hail "the size of hen eggs." The strangest rider on this storm was a nine-year-old girl named Samuel Phelps, who was crossing a sixty-foot-high railroad bridge over Fishing Creek near the Milledgeville depot, an umbrella held above her

A nine-year-old blown off a sixty-foot bridge over Fishing Creek by a strong gust of wind was saved when her umbrella acted as a parachute. *Illustration by Sarah Haynes.*

head for protection from the rain. A sudden blast of wind swept her off the bridge. "A lady who saw the whole affair from a short distance off, says she went down hanging to the umbrella, which was stretched over her head, in the fashion of a parachute, the handle of which broke, however, before she reached the ground."

Witnesses, fearing the child had been killed, rushed to her assistance but found her "comparatively little injured"; she only sprained an ankle. "Her preservation from death is probably owing to the fact that the small but strong umbrella acted as a parachute and that she fell on a small haw bush three or four feet high, both of which materially broke the force of her fall."

ODD PRECIPITATION

A Heavenly Faucet and a Phantom Grave Digger

In May 1865, Union cavalry under General James H. Wilson trekked across Georgia from Columbus and West Point to Macon, which promptly surrendered. The few Union casualties were initially buried at historic Rose Hill Cemetery, near the foot of the gentle slope overlooking the Ocmulgee River. Some years later, the Federal dead were transported to the large Nashville National Cemetery in Tennessee. Authorities admitted that they may have inadvertently left a few behind, and some cosmic tears seem to have fallen for them.

One day in October 1897, a crew of gravediggers was plying the trade when one man saw a narrow band of rain falling on that small burial plot. Intrigued, he approached and even walked under the gentle rain. Sexton Hall was notified, and he soon "stared in disbelief," reported the *Atlanta Constitution* of October 26. Hall sent word to the mayor to dispatch "a reputable citizen or city official." Captain Monroe Jones,

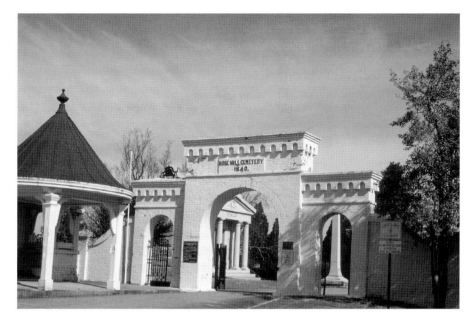

Rose Hill Cemetery in Macon contains the graves of three of the Allman brothers. Phantom gravediggers have been heard hard at work. *Jim Miles.*

chief of the fire department, responded and reported that the story "was perfectly true."

The odd rain continued for four days, attracting many curious citizens, all agreeing that the strange rain "cannot be accounted for." The rain fell from above and between two trees, a tall black gum and a hickory, although the sky remained bright and cloudless.

Five years earlier, according to Dennis Keating, a well-known and respected undertaker, it was "discovered that at a certain spot in the cemetery behind a hill, there could be heard the noise of picks digging away within the bosom of the earth," at times when no graves were being excavated.

The Constricted Rain

On the Shipp Place in Chattahoochee County, there was "a place where rain falls perpetually," according to the *Atlanta Constitution* on March 21, 1890. J.R. Parkham stated that the rain started March 14 on a small hill with a thin stand of trees that "covers a space of fifty square feet. The space is perfectly wet, and the leaves on the ground are full of water."

Parkham and G.A. McBryde witnessed the phenomenon eight days later, when there "was not a cloud be to seen in the sky, and the leaves everywhere except on the square, were as dry as tinder." According to Parkham, "I stood with the space between me and the sun, and saw the raindrops coming down steadily from the sky. I held out my handkerchief and it was soon saturated with water."

Many skeptics trooped to the site, but after a visit "have gone away convinced." Parkham speculated "that some powerful unknown substance attracts the moisture from the atmosphere."

Strange Weather: Pink Lightning

At about 10:00 p.m. on June 11, 2011, my wife, Earline, and I were returning home after a two-week western tour to celebrate our thirty-fifth wedding anniversary. Approaching Macon on Interstate 75, we both saw half a dozen instances of pink lightning in the distance. Ten miles north of Macon, we encountered a rainstorm so intense that we and other motorists pulled over to the side of the highway. As we rode the storm out, some of the most intense lightning strikes in our experience split the skies, accompanied by crashing thunderclaps.

Intrigued by the pink lightning, I immediately consulted the Internet when I got home. There were few authoritative answers for the phenomenon we observed. Most sources stated that the colors—produced by humidity, mist, dust and other matter that light travels through to get to our eyes—can produce red and pink lightning. Also, particles in the atmosphere can affect color by absorbing or diffracting portions of the white light produced by lightning. The distance from the observer and faraway city lights may cause this phenomenon. Pink as well as green hues have been reported from lightning and, rarely, in snowstorms.

Everybody Must Get Stoned

Meteorites occasionally fall from the heavens, but sometimes the stones are perfectly terrestrial, just delivered by unknown means.

In August 1885, a number of stone falls were witnessed on the property of James Matthews in Clarke County. Hundreds of the curious were attracted to the site, where few were disappointed as the stones fell regularly.

This phenomenon reportedly had a religious origin, as reported by the *Savannah Morning News*:

> *There is a woman living at the farm who professed religion about three weeks ago, and when she was converted she says God told her that He would follow her with rocks, but that she would not be hurt, and since that time rocks of various sizes have been falling through the house, and in one corner of the house the rocks have torn a great hole in the roof. If the woman is sitting in the door the rocks come through the corner of the roof and pass out by her. The woman says she is not afraid as God has promised to protect her.*

One early afternoon in February 1873, "a genuine shower of stones, varying in size from as large as a hen egg to that of a man's two fists," fell onto Covington Street in Walton County's Social Circle, according to the *Walton County Vidette*. The rocks were irregular in shape and colored a dark gray, with spots of a "bright shinny substance." "The shower was very brief," the account continued, "and extended over not more than four acres of ground, and followed an explosive sound not unlike cannonading."

A woman was slightly injured as one rock almost struck her. She "alarmed the neighborhood with her cries. As many as a dozen stones fell on the roof of the editor's house." This incident was declared to be "one of the strangest phenomena that ever was seen in Georgia."

In 1893, Oak Grove was a district near the Hammond Post Office, fourteen miles from Atlanta. For a week in mid-October 1883, according to the *Atlanta Constitution* of October 18, a rock thrower plagued the home of George T. Reeves, "a respected and honest farmer."

The trouble started when a daughter, Rachel, and an adopted daughter, Mattie, were in a field picking cotton. A rock fell near Rachel, who accused Mattie of tossing it at her, a charge refuted by Mattie. Soon a second rock landed near Mattie, who demanded to know why Rachel tried to hit her with the stone. Rachel denied the action, leading to an argument of several minutes' duration. Back at work, a third stone nearly struck Rachel, who accused Mattie of throwing all three rocks, including one at herself in order to divert suspicion.

At that point, their mother arrived, heard the girls out and proposed that a party of workers in a nearby field were the culprits. While she kept watch, a fourth rock nearly hit the girls, who were standing together. The guilty party was not visible.

During the night, a storm of stones, weighing up to a pound and a half, were propelled against the walls of their house and onto the roof. The following day, Mr. Reeves was stacking fodder "when a heavy stone struck him on the shoulder near the neck." He cast about but saw nothing. Several minutes later, a second rock fell nearby. The stones continued to descend, "and even when Reeves walked to his home rocks fell about him, sometimes very nearly striking him, and at times falling behind or in front of him. The home was bombarded through the night."

By the next morning, every household in the area had become aware of the problem, and many neighbors came to witness the continually falling rocks. Someone suggested a novel origin, that "the remnants of the end of a comets tail" were responsible. Few subscribed to that theory.

Sunday after dinner, fifty to one hundred area men gathered, all "armed to the teeth…hoping to locate the perpetrator and identify him." Searchers fanned out in every direction for a quarter mile from the house and then searched in parties. No culprit was found, and at first, the stoning ceased. However, half an hour into the search, the stones fell again, one near the porch and another against the side of the house, while four witnesses huddled inside. That night, additional stones descended onto the property.

The following morning at dawn, "the throwing commenced with renewed energy" for five or six hours, leaving the community "in a befuddled condition." One neighbor, W.J. Waits, said that "we are all pretty badly roused up in the neighborhood and we are determined to unearth the miscreants, whoever they may be." The newspaper thought that if the stone caster were ever found, "he will be dealt with severely by the party capturing him." After that morning, no more stones fell.

Our last report involves no stones but certainly stems from the same mysterious source. In early February 1883, a Mr. Adams of Montgomery County heard rapping, like someone was striking the exterior walls of his home with sticks. He immediately investigated, finding nothing, but then "the rapping started inside the home," according to the *New York Times* of March 1. A search of the home revealed nothing, and in the next few days, "the rapping grew ever more intense." Adams, described as "frightened and exasperated," tore out ceilings and walls, to no avail.

STRANGE SKY FRUIT

Many strange things have fallen from Georgia's skies, witnessed by many respected citizens and recorded in newspapers, beginning in 1811.

Egg Fall

Savannah witnessed a unique fall in the early spring of 1923. George D. Gattman was a patrolman for the Savannah Police Department, assigned to the Johnson Square beat. On a Tuesday night at 12:30 a.m., as the bells of city hall rang the time, the officer was at the intersection of Bull and Congress when, according to the *Savannah Morning News*, "he heard something drop with a slight thud on the Bull Street asphalt." Ten feet away, he found "the shell of a smashed egg, the yolk and the white." He wondered about its origin.

On the following night, at 12:02 a.m., Gattman was at the Liberty Bank Building when an egg hit two feet from the previous night's impact site. The patrolman anticipated another egg toss on Thursday night, and it fell at the expected time and place. Waiting again on Friday at 12:30 a.m., *two* eggs descended. The eggs seemed to fall straight down from the sky, not thrown at an angle from a building. According to the *Morning News*, Gattman wondered, "Are hens beginning to fly at night? Are they laying eggs in the air? If so were there two hens flying Friday night, instead of one?"

Fish Falls

Fish are associated with water, although they should be in bodies of water and not falling from the sky with rain. Fish fell from the Columbus sky during a fierce rainstorm in mid-April 1910. Not only fish fell but also eight-ounce pieces of hail and, reportedly, an alligator. The hail, "great jagged chunks of ice," damaged crops as it "at times descended in perfect showers," the papers reported. Several small fish were found on city streets, including a live trout three inches in length. A tornado had struck Alabama the previous day, and it was speculated that the creatures had been sucked into the sky by the funnel and deposited on Georgia.

In July 1845, according to the *Albany Patriot*, "They had a shower of fish during a gust at Louisville on Sunday. Some of them were three or four inches in length, and were alive and playful in the pools where they fell."

Thirty years later, a six-inch-long catfish reentered Georgia's atmosphere over Irwin County, according to the *Hawkinsville Dispatch*. On July 29, 1875, a dark thunder cloud passed over the farm of Lyman Dixon, located along the Ocmulgee River. Examining his cotton field afterward, Dixon found that lightning had struck and severely burned one-fourth of an acre. The bolt transferred its energy to a fence and killed weeds for a length of seventy-five feet, without causing any harm to the fence. The fish, found in the yard, "was placed in a tub of water, and was found swimming around the next morning."

Alligator Fall

Stephen Swain represented Emanuel County in the state legislature early in the nineteenth century. In the July 18, 1829 issue of the *Milledgeville Statesmen & Patriot*, Swain related an incident that occurred in the summer of 1811. After "an unusually black, turbid looking cloud passed," causing a short storm with torrential rain and extreme electrical activity, the senator decided to inspect his property. In a twenty-acre field one mile from his house, Swain "discovered a trail as if some animal had been dragged along the ground. Following it for a short distance, he discovered the dead body of a large ALLIGATOR, measuring between eight and nine feet in length."

Wanting to know where the gator originated, he followed a trail left by the animal to the center of the field, where "the earth was much torn up, exhibiting the appearance of having been crushed by the fall of a large limb of a tree, or some other body of great weight having fallen with great violence upon it." Swain thought that "there existed not a reason to doubt its having been ejected from the cloud just passed over." Injured by the fall, the gator had crawled one hundred yards and expired.

Also, "on the same day, and during the same fall of rain, several alligators, about 16 or 18 inches in length, fell in the neighborhood; one of them falling down the chimney of a house distant two or three miles from the field wherein the larger one was discovered." The creature "was perfectly smooth and polished," the belly "unusually white and shiny," as "if caused by constant friction," perhaps from reentry.

Frog Falls

The May 27, 1929 issue of the *Macon Telegraph* described a frog fall witnessed by B.F. Merritt, Macon alderman and mayor pro tem. He and his family were returning from Americus by car when a shower of frogs fell on the land. Mrs. Merritt also spotted a fish lying beside the highway.

Turtle Falls

At Milledgeville in late March 1891, George Caraker, a former Confederate captain, mayor of the city and longtime city clerk, was sitting in his door watching the rain when he "saw something fall from the clouds and bounce like a ball in his yard," the *Savannah Morning News* stated. "He went out to discover what it could be, and found a live terrapin, which had evidently descended with the rain from the clouds. The little animal was about an inch-and-a-half in circumference, was a dark green on its back, and striped—something like a king snake—underneath."

Strange precipitation in Georgia includes accounts of frogs, alligators, turtles and more raining from the sky. *Illustration by Sarah Haynes.*

"A terrapin about as large around as a silver dollar was the subject of a good deal of talk in Valdosta the other day," the *Savannah Morning News* revealed four years later, on September 8, 1895. During a strong rainstorm, the turtle landed in a street between a shoe shop and butcher, the fall witnessed by two adult men and a boy.

TELEPHONE CALLS FROM BEYOND

Over the ages, the dead have attempted to communicate through a variety of methods, their techniques changing with our technology. For a time, telephone calls from the dead were common occurrences, and in one odd case, it involved phone calls *about* the dead.

On April 12, 1990, four men boarded the snapper boat *Casie Nicole* in Darien and set off for a seven-day fishing expedition off the Georgia coast. The occupants were Nathan Neesmith; his brother, Billy Joe Neesmith; his nephew, Keith Wilkes; and a friend, Franklin Brantley.

During the voyage, the boat began riding lower in the water and became sluggish. When they realized that the boat was taking on water, they attempted to activate the ship's pumps, which failed to function. The men began bailing the water out with buckets, but the vessel continued to flounder. To make the situation even more dire, the radio was inoperable, and they could not summon emergency assistance.

The four men abandoned the boat and huddled in a single small life raft, which also began to leak from a quarter-sized hole. The raft was sinking when they spied a hatch cover from the *Casie Nicole*. The men climbed on top of it, but it was thrown about by the rough ocean.

Nathan Neesmith sighted their overturned boat at a distance of three to four miles and determined to swim to it, hoping he could attract assistance from it. The others attempted to dissuade him, but he set out swimming at 9:00 a.m. and reached it near dusk. He was exhausted by the effort and ill from ingesting a quantity of seawater.

Nathan clung to the ship's hull all night, losing sight of the others. The vessel continued to sink lower, and he transferred to a floating bait box from the boat. Nathan was finally spotted and rescued on April 15, but the others were never found.

A bizarre series of events followed this tragedy. Over the following year, seven strange telephone calls were received by Doug Tyson, the fishing boat's owner, and Nathan's sister. The caller was a man who spoke Spanish but did not understand English. During each call, he repeated the number he was calling and then recited each name of the missing men. He ignored any questions posed to him and then hung up. The seventh and final call ended with the unidentified caller saying, in broken English, that he would bring the three men home.

Of course, the men never returned. The families of the missing men wondered if they had been kidnapped or had floated to Central or South America. The odd calls gave false hope to those whose loved ones vanished twenty-seven years earlier.

Voodoo: Evil Spells, Conjure Bundles, Mojo and Root on the Coast

This tale involves not only voodoo but also an exorcism, a truly bizarre combination. During the fall shrimping season in 1983, the seventy-three-foot shrimp boat *Tornado II*, owned by Lawrence Jacobs and operated out of the tiny McIntosh County community of Valona, broke down or ran aground every time it left the dock.

Jacobs was readying the *Tornado II* for a long scallop mission to Florida when he found a curious object secreted in the bottom of a freezer on the boat. The package, tucked into the bottom of a large plastic cola bottle, was composed of bleached bones and weeds. Among the bones was "one long bone, about a foot long and about as big around as a pencil," Jacobs said. "I've never seen a bone like it before." A skull, perhaps a cat's, was "stuck right up on top," and the vegetation was "some kind of little straws or weeds or something you catch in your nets."

Jacobs, a native of McIntosh County, recognized this as a "conjure bundle." Some believe that such voodoo practices cast evil spells, but Jacobs rejected "that stuff" and jettisoned the artifact overboard. "I figured one of the other shrimpers had done it for a joke," Jacobs said. "But then later, when we got to thinking about it and all our problems with the *Tornado II*, Gay [Lawrence's wife] said we'd better get the boat blessed." Gay had also been told that a spell had been cast on the boat.

Sometime later, Gay was attending services at St. Andrews Episcopal Church in Darien when, "really just joking," she told her prayer group that the *Tornado II* was in need of an exorcism. "We had already asked [Reverend Wells Folsom] to come out and bless the boat," Gay said, but after the preacher learned of the conjure bundle, he asked his bishop for permission to perform an exorcism.

Father Folsom, admitting that this was his first time blessing a shrimp boat, anointed the vessel with oil blessed by the bishop, followed by a shower of holy water, and scripture was read. Lawrence, Gay and their three adult children stood quietly on deck during the ten-minute ceremony. Folsom gave Jacobs a bottle of holy water to keep on the boat, and one of their sons added a cross to the wheelhouse.

The exorcism "made a world of difference," Lawrence stated. "We didn't have anything but routine maintenance after that for months and months."

While not an everyday topic of conservation in coastal Georgia, the practice of voodoo, known locally as mojo, is not uncommon. "Around here,

Fleets of shrimp boats are based in coastal Georgia. Some have suffered from the effects of voodoo curses. *Earline Miles.*

people talk about it like they talk about the sunshine," Lawrence said. He had heard shrimp boat captains talking on their radios "about putting a spell on someone or taking out a root, stuff like that."

Father Folsom also served as priest of St. Cyprian's Episcopal Church, which had a predominately African American congregation. He had visited homes of parishioners and occasionally saw "fetish dolls," and he knew that love potions were bought and sold. The minister also heard that some McIntosh residents claimed the ability to divine the future by reading entrails of freshly killed chickens. He believed that about fifty residents still practiced mojo, although he found it difficult to get people to talk about the practice.

Folsom thought voodoo was brought to the Georgia coast by African slaves hundreds of years ago. Most of its practitioners were older, but some younger people were "taking up the habit," drawn by mojo's connection to African history. Folsom took advantage of the controversy in McIntosh County to condemn voodoo/mojo. He referred to the shrimp boat curse and exorcism when he preached a sermon at St. Andrews about Jesus casting out demons.

On a personal note, during my thirty-year reign as a high school teacher, I occasionally overheard conversations about spell casting. One time, an upset student threatened to hex me. She was shocked when I told her to go right ahead. I don't know if she did or not, but my life was unaffected.

Voodoo: From the New York Times

You can find the strangest things in the archives of that great American newspaper the *New York Times*. One of these items was published on June 21, 1888, under the headline "VOODOOISM IN GEORGIA."

It was reported that the wife of Reverend Tom Thomas, a respected clergyman of Sandersville in Washington County, "felt a peculiar pain in her limbs which gradually enveloped the entire body." When common remedies were applied, "each dose administered seemed to augment her suffering."

Thomas eventually decided that his wife had been "bewitched" and sought the services of Gus Cheevers, a partial Native American man "noted for his knowledge of occult sciences. The old doctor told Tom that his wife had been poisoned with rattlesnake poison by a neighbor."

If left untreated for another three days, she would surely die, but for a consideration of eighteen dollars, Cheevers "undertook to antidote the poison." His concoction would "at 12 o'clock on a certain day make her sick almost unto death, but after that she would get well." The treatment caused the poison to be "exuded from the pores of her skin in threadlike sprays of mucous."

The woman recovered at the promised time and was soon back at work hoeing cotton. Later, the voodoo doctor returned to the Thomas house to identify the perpetrator. "This he pretended to accomplish with a talismanic ball pendant from a string. The neighbors assembled, and the ball was held up in front of each as his name was called, until Boston May was reached, when the ball flew toward him." The indicated man immediately denied guilt.

Living adjacent to the property of Thomas was "Old Man Jerry," whose well "began boiling up…and whenever a bucket of water is drawn it begins to foam and run over until the bucket is empty. The wondrous little ball also lays this devilment to Boston, and the old doctor says the cause is a little bottle of poison placed in the bottom of the well."

Ah, the medical and forensics sciences of yesteryear.

ESP

In February 1938, Dr. Raleigh M. Drake, associate professor of psychology at Wesleyan College in Macon, announced the extraordinary results of an ESP experiment he had conducted with an eleven-year-old boy. Using standard ESP cards containing stars, squares, crosses and wavy lines, the boy gave correct answers 439 times out of 678 tries, or 16.5 out of every 25. At one point, he was correct 12 times in a row and at 11 different times had runs of 7.

However, only the boy's mother tested him, which suggests that she had some ESP gifts herself. The boy was blindfolded and placed in a different room from his mother, who held cards and concentrated on them.

Dr. C.W. Bruce, Wesleyan math professor, worked out the probability of getting the right answers by chance of being one in a trillion raised to the thirteenth power. Makes my head ache.

Dr. Drake, who had been a skeptic regarding ESP before this experience, said that the boy was surprisingly accurate in identifying figures, page numbers and words thought by his mother. He was also reported to be able to read the minds of playmates and others.

The boy had originally been referred for a reading problem by a former student of Drake's.

LIFE AFTER LIFE

Long before Dr. Raymond Moody made the life-after-life experience a common topic, an OBE (out-of-body experience) occurred in 1880 in Paulding County. A resident named Rast Bone had his throat cut in some unfortunate incident, but he survived and breathed through a silver tube inserted into his throat and secured by fine silver wires attached to his lower jaw.

Over time, the wires corroded. When they broke, the tube fell into Bone's throat and obstructed his breathing. He fell to the floor and apparently "died" because his soul left the body and floated up toward the ceiling. He remembered looking down on his body and thinking how easy it would be for someone to extract the tube. However, he hoped no one would.

But someone did, obviously, or how could the story be told? Rast lived many additional years and often told the story.

BIZARRE GEORGIA CREATURES

I have proudly chronicled Georgia's impressive cryptids, a class of apparently living creatures suspected by some to exist but rejected by mainstream science. This study is called cryptozoology. In the past, I concentrated on Bigfoot and our water monster named Altamahaha, but here I feature other denizens of Georgia's strange menagerie.

THE ANGELS OR GHOSTS OR FAIRIES ON WAHOO CREEK

On Wednesday, July 15, 1896, according to the *Newnan Advertiser*, a citizen was three miles from town on Wahoo Creek when he witnessed a "strange and thrilling apparition" that "baffles all attempts at explanation." Although previously an unbeliever in "spirit manifestations," his experiences "have shaken his faith very much" and left him "ready to believe in anything." What he saw could have been described as angels or ghosts or even fairies.

That morning, he was "in a very dense section of bushes and trees" along the banks of the stream. There he came upon "five strange looking creatures—one of whom was very tall and slender, wearing a thin garment of white and black, with a hat neither ancient nor modern, but similar to those worn by a Texas cowboy, and arms long and tapering, with fair and lily-white hands—another not quite so tall but large and broad shouldered, with a voice similar"

to a bird's and whose dress was "much longer in the train and more difficult to carry through the weeds and briars—another wore a peculiar and thin wrapper, antique in appearance, yet artistic in design. It veiled a lithe-like form that would have done for a model…of a Raphael [and] glided about over the rocks and cliffs with perfect ease. This creature-human or spirit—he could not divine which—had for companions two little mermaids." Each creature was "eating blackberries, not plucking them with their hands as people generally do, but gathering them with their bills like birds."

The account continued: "Whenever they wanted to go from one bank of the stream to the other they flitted across the water like wrens jumping from log to log in a wood pile. Finally, having slated their appetites, they suddenly disappeared in the water like young ducks diving for insects in a shallow stream. After regaling themselves for some time they then returned through the woods, flying up into the trees and hanging to the limbs like sapsuckers to a dead pine, and leaping the railroad cut above the bridge without the slightest effort."

As darkness descended, the figures moved uphill to a cemetery, where they easily leaped a tall fence. The witness used the gate to enter the graveyard and from behind a screen of bushes "discovered these creatures sitting on a tombstone, who, on his approach, raised their arms, gave a hideous shrill cry, and vanished like mist before the sunlight."

The man stood "motionless and speechless, not believing what he had seen, but knowing that he was in his right mind."

THE DUCKGATOR MONSTER OF SCREVEN COUNTY

The Savannah River has extensive swamps and wetlands. The river flooded during the winter of 1895, driving "out of the swamp all the animals and birds that are known to this part of the country, and large quantities of game were killed by the hunters," declared the *Sylvania Telephone* in its February 7, 1895 edition, reprinted by the *Savannah Morning News* on February 18.

The *Telephone* had received a detailed account of an experienced hunter who was in the swamp hoping to bag a deer. He was near the junction of Briar Creek and the Savannah, where "the swamp is four or five miles thick and in many places impenetrable," the paper noted.

The witness was hiding behind a tree at a lagoon. As he waited patiently, he heard a sound coming from the swamp "that made my hair stand on end,

a peculiar sound somewhat like the quacking of a duck and the hissing of a snake combined…it was stronger and louder than either, and yet that is the impression it gave me—either that it was a monster duck or else a huge snake"—or both.

Believing that the sound emanated from a certain spot toward the river, he focused on that location, gun loaded. "In a few seconds I heard a kind of splashing in the water, and peering through the bushes I saw, about a hundred yards away, what seemed to be the head of an enormous duck. But I thought surely, it was the king of all the ducks—for the bill was at least a foot long and as black as could be. It was still making that blood-curdling, half hissing, half quacking noise, and seemed to be wading or swimming slowly along in the mud and water."

Suddenly the creature "raised itself up a little, and I saw the blackest, ugliest, most loathsome-looking animal that ever inhabited this earth. I do firmly believe its body was between three and four feet [long], and was also black." As more of it came into view, he thought it looked like "an alligator coming out to sun himself." The creature approached, and as it crested a knoll at the water's edge, he "had an opportunity to see the thing in all its strangeness and ugliness."

The creature, dubbed a "horror of horrors," was seen to have but two legs, which surprised him. "As near as I could judge, its legs were about a foot and a half long, and it stood there like some huge, black bird of the night, with its bill stuck downward and still emitting that unearthly kind of noise."

The hunter was so paralyzed with fear of this "duckgator" that it "never occurred to him to use his gun," a common reaction when hunters encounter Bigfoot and other cryptids. He also believed that he would have died of fear before the creature reached him and "would rather have faced a thousand alligators than that bird, or beast, or whatever you might call it."

The creature was in full view for two minutes, giving the hunter time to examine it. "Its body was rough and scaly like an alligator's, and the tail went off to a point. It had legs like a turkey or duck, only they were larger and longer…It kept turning its bill up and down and around, but try as I could I never did locate its eyes." Despite this sight, it was the cry that shook the hunter most. "I can never describe to you the awful sound the thing made with its mouth. It made my blood run cold every time I heard it."

The fantastic creature had one additional surprise for the witness when it "gave a kind of spring from the ground, and before I could realize what it was doing it went up into a large tree and sat on the lowest limb. Amazed, he "saw two dark wings spread out from its side and strike the air with a heavy

sound." He observed no feathers, and when it had balanced, "its wings were drawn so closely to its body that it was impossible to detect where they were." In the tree, the creature had its back to the hunter, who realized it was a perfect opportunity to leave, not taking "a long breath until I had left the swamp a full half mile behind."

Later that day, the man returned with four other hunters, who "could plainly trace where it had crawled along in the mud and also where it had stood on the soft little knoll." The hunter admitted that he was no naturalist and knew little about animals and birds. "It may be a regular species," he allowed, but he had not seen anything like it. However, he said, "I am convinced that this thing that I saw was the unnatural offspring of two animals—or it may have been an animal and fowl, that should not have cohabited together." He concluded that "it was a monstrosity, something that should not have been and was not intended to be—a cross between a beast and bird."

THE INFAMOUS MOTHMAN COMETH TO GEORGIA

Mothman, famous in paranormal lore (read John Keel's classic book *The Mothman Prophecies*), plagued Port Pleasant, West Virginia, between November 1966 and December 1967. Described as man-shaped, very broad, seven feet in height and gray in color, its prominent features were great wings attached to its back and giant, glowing red eyes that some witnesses found hypnotic. Mothman flew fast enough to pace a car doing one hundred miles per hour. It was considered a harbinger, culminating in the collapse of the Silver Bridge over the Ohio River at Point Pleasant on December 15, 1967, that killed forty-six people. The being has been seen at other places.

On July 12, 2011, Lon Stricker posted on his Phantoms & Monsters website, "Witness: The North Georgia Mothman." The witness, labeled "EW," had contacted Lon with her account. It took him six months to persuade EW to allow her story to be told, with names and specific location omitted.

The incident had occurred three years earlier when EW was twenty-five years old. At 11:30 p.m., she was driving on a rural road through the quiet night to a friend's house, tailed by an aunt in a pickup truck. EW turned on the radio, but it had apparently stopped working, although she "started to hear weird scratching sounds coming through the speakers," she wrote. "It sounded like a distant voice but I couldn't understand what it was saying…

A winged humanoid with no head and glowing red eyes was reported in North Georgia in the early twenty-first century. *Illustration by Sarah Haynes.*

Suddenly, something flew in front of the car and hit the windshield with enough size and force that it totally mangled the grill and hood."

Shocked, EW slammed on the brakes and "heard what sounded like wings flapping on the roof, but then something rolled down the back window onto the trunk then eventually on to the road. I thought I killed whatever it was."

EW's aunt had witnessed the object fall to the pavement. When she and her niece noticed the creature's eyes "glaring bright red" and saw that the being "resembled a man with large bat-like wings," auntie returned to the truck and brought out a shotgun, which she pointed at the cryptid.

The women backed away as the creature started to revive, and the aunt racked a round into her weapon. "It slowly stood up on two large raptor-like claws," EW continued, "turned and stared directly at us with those terrible

bright red eyes.…It slowly levitated off the ground with wings spread until it was about 10 foot up, then instantly, it let out a deafening screech as it just disappeared with a loud 'swoosh.'"

EW and her aunt put together a detailed description: "This thing had the body of a well-built man. It had no feathers but charcoal gray skin like that of a bat with some hair on the shoulders and around the eyes and legs. When it spread its wings, it had the span of 12 foot or more. I estimate it was about 8 foot tall. It had no head, however, just the eyes embedded on the shoulders that had brows. I didn't notice a mouth or nose."

Rattled, EW spent the night with her friend. The light of morning revealed "a huge crack in the windshield and the grill was mangled beyond repair. The hood also had a deep 25-inch dent."

Walking back toward the house, EW noticed a shape in the grass. It was the friend's golden retriever, "lying dead from massive lacerations up and down its back. I just knew that thing did it." Retaliation, one suspects, for the hit-and-fly incident. Three years later, "I constantly dream of this creature," EW wrote.

Lon Stricker spoke with the woman and declared, "I have no doubt she witnessed a winged humanoid and most likely a Mothman."

Really Big Birds

A number of large avian creatures were spotted flapping above Georgia starting in early July 1947. On a Sunday afternoon, J.C. Anderson, a resident of Spring Street in Gainesville, saw an enormous bird high overhead. The creature was black and resembled "something like a buzzard," he said, but it had an estimated wingspan of thirty to thirty-five feet. When asked by a reporter if it could have been an airplane, Anderson snapped, "Did you ever see an airplane flapping its wings?"

Ancient Pterosaurs Over Georgia

Pterosaurs, the oldest vertebrates that had powered flight, existed between 210 and 65 million years ago, although some believe they are still around.

Jonathon D. Whitcomb is the modern chronicler of pterosaurs with his blog *Modern Pterosaur* and three books on the topic. Whitcomb has received

sighting reports from three different individuals in Georgia—one has made four separate sightings, while another has had two encounters.

"The bird was a uniform tan in color, with a long tail....The head was 'Curved, like a hammer.'" *Illustration by Sarah Haynes.*

We start this extraordinary report with Sandra Paradise of Winder, whose experiences started on August 27, 2008. She has a twenty-five-mile commute to work, the route alternating between pastures and forests.

Paradise had risen early that day and was on the road at 7:00 a.m. when a winged creature flew just in front of her car and just above it. "What was that!" she yelled to herself. The bird was a uniform tan in color, with a long tail ending in a heart-shaped feature and a ridge on the underside of the impressive tail. The head was "curved, like a hammer," and the crest was "solid, not feathery at all." She thought it "made perfect sense as it flew" and described the creature's actions as "dive bombing my car." She phoned a friend to say, "You won't believe what I just saw!"—a pterodactyl.

Two weeks later, September 10, Paradise left home under a cloudy sky running late. It was 9:00 a.m., and she was a few miles out of town when she spotted a larger version of the same aerial being. Again, she saw the long tail, the thick end and a head crest. This creature was actively flying—the wings pumping in a scooping motion, the effect rippling through the body and tail. She compared it to a "breast stroke" or grabbing at the air and pulling itself through the sky.

This second creature was as long as her Camry and the size of a large dog or even a tall human. The initial beast had been about as wide as her Camry.

The third sighting occurred in October 2008 on the same road and near the second sighting. A flock of crows flew across the highway in front of her, followed by a pterosaur.

Around early January 2011, she thought that the same creature passed directly above her, "wings outstretched, distinctive head in full view, pad on the tail." The creature "was traveling fast, with a distinctive, quick, 1, 2, 3, rest [with wings outstretched] 1, 2, 3, rest, wing beats." She once saw the shadow of what was obviously an unusually large bird fly into the woods near dusk.

Other reports originated in southwestern Georgia when a woman and her son were driving and both saw "a large thing, not a bird," that resembled a small pterodactyl with bat wings and a wingspan of ten feet. It "had no discernable feathers," and the son said it had "leathery-looking skin." The head was pointed and the tail end a diamond, with legs pointing backward. At a later date, the same woman and her fourteen-year-old daughter were on the road, no more than three miles from the original sighting. This time, the view was clear, and the event lasted longer. The woman said she was reminded "of the creatures at the end of *Jurassic Park*" and noted that they were nothing like the turkey vultures routinely seen in the area.

WEREWOLVES OF GEORGIA

The Werecat of Fannin County

"One of the most remarkable accounts of lycanthropy comes from Fannin County, Georgia," wrote folklorist C.S. Skinner in his 1903 book, *American Myths and Legends*. According to this tale, a man operating a mill along a mountain stream lived in a room beside the grinding operation. He was suddenly taken ill by a terrible disease with no discernable cause, or so the local physician decided. As he lay dying, the man attempted to communicate some important details of the affliction, "but his gestures were feeble and his words rambling," Skinner wrote.

The milling profession provides a good living, and men lined up to take on the job, at least until others were struck down by the same disease—sudden, terrible and mysterious. After the second and third millers died, the facility remained unused for a time, having acquired a reputation of being cursed.

Eventually, a man who lived nearby along the same stream announced that he would resume operations if he could purchase the property for a good price, a condition that was readily granted. The mill's new owner cut a load of wood with his axe, started a blaze in the fireplace and settled down for the evening.

As he enjoyed the quiet, a cat climbed out of the chimney and began quietly roving about the room, occasionally rubbing against the man's legs. Feeling that misfortune was imminent, he took out his Bible and read scriptures diligently. The cat seemed to become uncomfortable and sought to leave, mewling and scratching at the door while glancing sideways at the

miller, who ignored the animal and continued reading the Holy Book. Then the man looked down to see "the animal crouched before him with a baleful light in her eyes—eyes he had seen before, and not in the head of a cat," the account related.

Frightened and repulsed, the man sprang from his chair, grabbed his axe and swung it at the cat, lopping off a forefoot. "With a woman's scream, the cat leaped up the chimney and disappeared," Skinner wrote. Deeply troubled, the miller hurried home and found that his wife, "in her human shape once more, had lost a hand." She quickly bled to death, and the millers thereafter lived in peace.

The Lycanthrope of Coastal Georgia

Linda S. Godfrey is a weird colleague of mine, having co-authored *Weird Wisconsin*, *Weird Michigan* and several books about werewolves. In her *Hunting the American Werewolf*, there is a chapter titled "Georgia Werewolves on My Mind," which she kindly allowed me to pillage.

In June 2005, Linda received a telephone call relating "one of the best sightings yet, one that would actually leave me frightened," she wrote. The call came from Andy, a part Seminole marine veteran of two wars (twice wounded), a funeral director and an avid outdoorsman and hunter. He and others leased land seventy miles south of Savannah and twenty miles inland, which means swampy terrain, perfect for hunting wild hogs and other game.

Andy had spent the day searching for arrowheads. Near dark, he had returned to his truck when he glanced up a logging road and spotted a strange animal. Andy grabbed his rifle and approached the figure. From a distance of thirty yards, it turned and "stared at me," making a low growling sound, he said. "I was going to shoot it, and when I put the rifle up it leaped off the road and into the swamp," trailing a four-inch-long tuft of hair.

Andy had gotten a good look at the creature. The face was doglike, with "a long snout, and tall ears that pointed up," ending with tufts of hair. It also had thick,

The wolfman of Coastal Georgia had a doglike face but stood an estimated six and a half feet tall with a muscular, humanoid body. *Illustration by Sarah Haynes.*

six-inch-long whiskers. The coloring was brown and black with reddish areas. The fur was short at its feet but became shaggier up the body to a length of several inches. Andy estimated it weighed up to 275 pounds and stood at least six and a half feet tall, with yellow glowing eyes and black pupils. Within the open mouth, Andy saw teeth nearly two inches long. The animal had a formidable stench.

The apparition was not only large but also muscular, "like a body builder." The legs were shaped like a dog's but with much larger feet, and its arms ended with human-like hands, long fingers and three-inch claws.

Andy examined its tracks, finding that it had four toes with claw points. His size-eleven boot fit neatly inside the prints. Andy returned two weeks later in the company of a cousin, who dismissed the werewolf story. However, for additional security, they had brought three hunting dogs.

Half a mile from the initial sighting and again at dusk, the mystery creature was spotted at the edge of the woods, staring at them with its glowing yellow eyes. "That's the werewolf!" Andy cried. He snatched up his rifle as Billy, initially stunned, unleashed three bulldog-mastiffs, each weighing about seventy-five pounds.

The creature, unafraid of firearms, charged. "It was trying to get me," Andy said. When the three dogs leaped from the truck, the werewolf stopped suddenly, leaped fifteen feet and tore through the brush on all four legs. The dogs returned thirty minutes later, exhausted but unbloodied.

These experiences explained several mysteries that Andy had noted before: "I have found hogs disemboweled, and a gator that was ripped up and had his tail torn off on this land." As a child, Andy had heard stories of werewolves numerous times, and his grandmother had spread sulfur around her house in order to keep such creatures away. Linda Godfrey was impressed by this experience, citing Andy's training in anatomy and his hunting experience.

On a related note, Georgia has hundreds of Bigfoot reports but no stories of vampires, so if you have seen the undead, let me know.

It's a Wereswan

C.S. Skinner also wrote that "evil beings" do not solely take the form of werewolves, but also humans and even birds. In southwest Georgia's Kinchefoonee Swamp, where plentiful bream were caught during daylight, no outdoorsmen ventured after sundown. The area "was for a long time the

A banshee often appeared to announce deaths in the Williams family at the Homestead in Milledgeville. *Earline Miles.*

home of a swan" that "was an evil spirit in disguise" and "carried trouble and illness to every settlement in which it was seen."

Many attempts to kill the swan with rifle fire were unsuccessful for many years. Finally, an army officer shot the dirty bird through the heart, "and by general consensus the illness and trouble ceased on that day."

WAIL OF THE BANSHEE

The Ferguson House, now known as the Homestead, was constructed in 1818 in Milledgeville on the corner of West Washington and South Liberty. Builder Peter Jones Williams presented it to his bride, Lucinda Parke of Greensboro. The house remained in the possession of a direct descendant of the family for generations.

The Homestead served as the center of Milledgeville's social life for a century, particularly in the early years, hosting governors, state legislators and other officials. One occasional resident of the house was a banshee, a creature that may have been a member of the clan in Wales, the ancestral

homeland of the Williams family, and followed its kin across the Atlantic Ocean when the family immigrated. These loyal spirits attach themselves to a single family.

Throughout the history of the house, the banshee has made unsettling and certainly unwelcome periodic visits to the family, often during happy occasions, to either herald the immediate death of someone or to vocally mourn one who has just died. On the latter occasions, it wailed or keened in mourning.

In the early decades of its existence, the banshee would appear to foretell a death in the clan. The banshee, which took the form of a little old lady dressed in gray from head to toe, would appear in the treasured boxwood gardens or on the grand staircase as the sun began to set, an appropriate time to accomplish its macabre mission.

Unfortunately, the banshee was a regular visitor during the 1860s, when she made three appearances to announce the deaths of three sons of Susannah "Miss Sue" Williams and her husband, Jack Jones, according to Barbara Duffey in *Banshees, Bugles, and Belles: True Ghost Stories of Georgia*. On each occasion, her appearance was quite public, happening in front of many dinner party guests.

All types of strangeness happens on isolated roads across Georgia, particularly on dark nights. *Jim Miles.*

A more recent visit occurred in the 1930s, when the banshee was witnessed by Frances Ferguson. Upon seeing the creature, Frances knew that her sister had died.

Since that time, the female spirit has been witnessed at the Homestead, although not in its usual role as a harbinger. In 1969, a resident fell asleep on a couch inside the library and dreamed of an early party, dating to the 1840s based on the attendees clothing. At the end of the party, everyone had left except one small, elderly woman wearing a long gray dress who sat in a corner of the library. The man greeted the lady politely, and at length, the lady said to him, "You'll never have to worry." The resident then awoke. Perhaps the banshee was reassuring him that there would be no family deaths during his tenure there.

Also in the 1960s, a male guest observed a gray-clad woman emerge from an upstairs bedroom. She checked each room and then descended the great staircase. At the front of the house, she stopped and looked back and then passed *through* the closed front door, through the boxwood gardens to Washington Street and then walked rapidly to Memory Hill Cemetery, where she vanished at the gate and since has never returned to the Homestead. Perhaps she wanted a last look around the old family home.

The Louisville Devil, a Banshee

In *Haunted Augusta & Local Legends*, Sean Joiner described the Louisville Devil, a supernatural being that in earlier days roamed the dirt roads of Jefferson County seeking out those who were soon to die. Most locals denied its reality, but a superstitious part of their brains dreaded its appearance.

At the end of a long day in Louisville, a family was returning to their rural home in an old Model T Ford, dust streaming into the air as they passed fields white with maturing cotton. Sisters Maggie and Blanche occupied the back seat, while their Aunt Rachel bored the driver with inane chatter in front.

As they neared home, a "small creature" materialized along the side of the road and then vaulted onto the hood of the car. The evil-looking being "posed itself in a hunched over position watching the family intently," its fiery eyes reflecting the light. "A grin fell across the creature's face with his lips parting, producing jagged teeth hugging a black flickering tongue. Slowly it stretched out a bony arm and pointed a small finger in Aunt Rachel's direction."

All four people in the Model T were horrified by the spirit, which vanished instantly, leaving everyone stunned. All realized they had just been visited by the Louisville Devil. Within two weeks, Rachel suddenly fell ill and died. The legendary death creature of Jefferson County had struck again.

Georgia Sea Monsters

I have written extensively about Altamahaha, the famous Georgia monster that frequents the Altamahaha River near Darien. Further research has turned up larger sea monsters along the coast and several additional freshwater creatures.

Ann Davis, Altamahaha's folklorist, discovered the earliest published account of the ocean creature that came from the April 9, 1830 edition of the *New York Spectator*.

When the schooner *Eagle* arrived in Charleston, South Carolina, on March 27, 1830, its captain, a man named Delany, went to the *Charleston Courier* and told an odd tale, "to the truth on which he declares himself willing, with his whole crew, to make affidavit," the newspaper stated.

At 10:00 a.m. on March 22, the *Eagle* was one mile inside St. Simon's Bar when the crew "observed at the distance of 300 yards, a large object resembling an alligator, occasionally moving along in the same course with the vessel, and at times lying nearly motionless upon the surface."

Captain Delany approached to within twenty-five yards of the creature, loaded a musket, lay on the deck for stability and fired at the back of the animal's head, "the ball evidently taking effect," the account continued. "Instantly, to the no small astonishment and apprehension of the crew, the monster aroused and made directly for the vessel, contracting his body, and giving two or three tremendous sweeps with his tail as he passed, the first striking the stern, and producing a shock which was very sensibly felt by all on board."

Fearful, the captain and crew leaped on their cargo, cotton bales loaded on deck, for safety. All aboard had excellent views of the monster before, during and after its counterattack "and concur in describing him as upward of 70 feet in length, his body as large, or larger than a 60 gallon cask; of a grey color, shaped like an eel—without any visible fins, and apparently covered with scales—the back being full of 'joints' or 'bunches.' The head and mouth resembled those of an Alligator, the former about 10 feet long, and as large as a hogshead!"

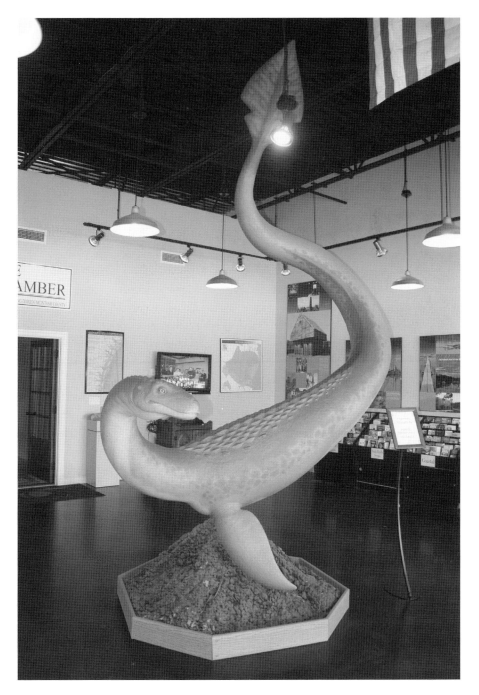

Altamahaha has been seen hundreds of times, but early sea captains sighted much larger sea monsters off the coast. *Earline Miles.*

An identical but smaller creature was spotted farther away. It submerged when the shot was fired, and "both were afterward seen together" disappearing into the distance. Perhaps the aggressive creature was protecting its mate.

He felt "that this formidable non-descript had sufficient strength to injure seriously, if not destroy, a vessel of the *Eagle*'s size, by a single blow fairly given, and deems himself very fortunate in the result of the encounter." The captain had reloaded his musket but "felt no disposition to renew the contest with so potent an adversary."

Delany had spotted "a similar creature off Dooby, about 4 years since, at which he fired three shots but without obtaining quite as familiar an interview as in the present instance."

On March 7, 1855, Amelia Matilda Murray was aboard the steamer *Isabel* when she took up pen and wrote, "I have heard of the genuine sea-serpent at last! Last spring, when Captain Peat of the steamer *William Seabrook*, was going up an island portion of the Savannah River, he, as well as his crew and passengers, saw a gigantic serpent just before the vessel; it quickly disappeared; a notice of the circumstance was inserted in a local newspaper, and treated with the usual incredulity."

Murray continued, stating that her captain, Rollins, "disbelieved the report; but the next day, during the passage of this steamer to Savannah, on approaching the bar of St. Helena [Sound], he was called by his look-out man to see 'the biggest log that ever was.' On looking through his telescope, he clearly saw that the object in question was no tree, but a monster as long as the *Isabel* herself, in rapid motion; as he watched it, it reared its snake-like body and head high out of the water as the funnel of the steamer, looked about for an instant, and then plunged down, leaving a swirling eddy where it had shown itself."

Murray described Captain Rollins as a calm, practical man, not given to "exaggeration or error in describing a fact." Murray believed this was "the first time that the sea-serpent has been supposed to be seen or heard of in southern latitudes." This missive was included as "Letter XX" in Murray's *Letters from the United States, Cuba, and Canada*, originally published in 1856 and widely available today in both print and electronic forms.

GEORGIA'S FRESHWATER MONSTERS

Another mysterious aquatic creature was spotted in the Savannah River at Augusta by three men, including a police officer. The story, in the May 16, 1878 issue of the *Savannah Morning News*, was reprinted from the *Augusta Chronicle & Constitutionalist*.

One day, near dusk, a policeman was patrolling the riverbank near the bridge when he noticed "a singular looking object floating down the river." The object was white and resembled a large box or bundle. The officer followed it down the river to Lincoln Street, where he called out to two men and asked them to find a boat and chase the unidentified floating object.

The men found a boat, jumped in, took up paddles and rapidly pursued the object. However, when it reached the mouth of Fox Creek, "it turned into it and proceeded up that stream, thus seeming to preclude the idea that it was an inanimate object." The men picked up the pace and closed the distance until one was able to touch the thing with a paddle, inducing it to leave the water and scoot onto the shore.

The men continued paddling upstream until one sprang from the boat and "started around to head off the mysterious object." Shortly, his mate in the boat began crying out in alarm for the man to return, saying "that such things had been seen around there before" and were to be feared. The first man hurried back to the boat, and they paddled furiously to the spot where they had obtained the vessel. The men "gave Chief Christian a graphic account of the occurrence," the newspaper concluded.

STRANGE DOGS

The Illuminated Ghost Dog

It was a Tuesday night, December 5, 1882, when "A Very Large Dog with a Lamp Perched upon AN APPARITION" appeared at the home of John A. Harvill in Laurens County, according to the *Dublin Gazette*. He and his wife had been sitting fireside "when a noise resembling that of a squeaking cart or wagon" was heard outside. They ignored it until the sound stopped outside their house, although the noise continued without movement.

Mr. Harvill opened the door to find an enormous dog with a lighted lamp balanced on its head. He called to the animal several times, hoping it was a

neighbor's prank, but there was no response. Shaken, he fired several shots at the apparition, "but to his utter astonishment and amazement" the dog stood still.

The gunshot attracted neighbors, who congregated and agreed on a plan of attack. They had lit torches when the creature lurched into motion, "accompanied by the same squeaking noise." Another area resident told a reporter that he had previously seen the phantom creature, but it had emitted no noise.

The Red Demon Dog

Oglethorpe County had a curious quadruped problem in 1889, according to the article "A Ghost in Goosepond," which appeared in the *Atlanta Constitution* on May 27.

A road in the county had long been considered haunted, and beginning several years earlier, "a strange looking wild animal," reddish in color, appeared before a solitary traveler. If the witness rode a horse or a horse-drawn wagon, the demon arose beneath the wheels of the wagon or under the feet of the horse. When frightened victims attempted to strike it with a whip, it instantly vanished. It vexed numerous travelers for several months. Curiously, every witness during this time was white, and when the phenomenon reemerged several years later, it appeared only to African Americans.

Several days before the press account, Perry Mattox was on the road when "a strange little red colored quadruped, about the size of a feist dog, or perhaps somewhat larger," appeared before his wagon, and the mules "became terrified and frightened." Mattox barely kept them under control, but when they slowed, so did the creature, "so as to keep a certain distance. When the being neared an old graveyard, "the apparition seemed to glide among the tombs and then vanished."

Of course, Mattox had been frightened and considered his apparition to be a spirit. Subsequently, other citizens encountered the creature, but only to single witnesses around midnight. It once sped between the legs of a man, "and he says he could not feel it touch him." It vanished but instantly reappeared ten feet in front of him. It also disappeared into the cemetery.

Jordan's Big Black Dog

My students were well aware of my interest in the supernatural. One day after class, Jordan approached me saying, "I don't know if this is ghostly or not, but this past weekend I went with my parents to the cemetery to place some flowers. I wandered off by myself, just looking around. In the distance, I saw a big black dog. I looked away for a second, then glanced back and this giant dog was standing right beside me. It scared the daylights out of me. It looked like a real dog, but it wasn't breathing. I closed my eyes for a moment, and when I opened them, the dog had vanished. Was that supernatural?"

"Yes," I replied, particularly in cemeteries. While teaching the Civil War, I mentioned that Chickamauga meant "river of death." "Oh my God," Jordan wailed. "I live on the river of death!" She did indeed live on Chickamauga Street.

A True Dogfish

In 1894, men hunting near the Alapaha River in southern Georgia heard what they assumed was the loud barking of a dog, according to the *Atlanta Constitution* of August 27, 1894. When the barking continued, they assumed that the animal had treed game and followed the sounds to what they hoped would be an easy kill. Coming upon the river, they were astounded to find something "that made their hair stand on end": "There, lying on the sand bed, was an immense fish, the body and tail being perfect, but, instead of the regulation head, the monsters head was shaped like an English bulldog with great rows of teeth glistening in the sun, and all the time the creature was baying as if about to attack something."

The startled hunters hadn't considered shooting the bizarre creature before it "glided into deep water and disappeared, the same dismal harking being heard once or twice after it went under."

SNAKE-HEADED FISH

On May 26, 1891, the *Atlanta Constitution* reported that a "LARGE AND CURIOUS FISH" had been caught in a Calhoun County creek. "Its head resembled that of a snake, and had teeth like a human being," read the account. "It is of a variety unknown to the oldest fishermen." One wonders if it made "good eatin'?"

Supernatural Monster

In the *Atlanta Constitution* of August 18, 1882, Georgians learned that "A Supernatural Monster" had been encountered repeatedly in a swamp near the home of Rufus T. Beechman, apparently somewhere in Central Georgia. "Dogs and guns have so far proved useless" in subduing the creature. No further details were offered.

Expedition Bigfoot

The most exciting development in Georgia cryptozoology was the 2016 opening of Expedition Bigfoot, a museum dedicated to all things Bigfoot. It is operated near Blue Ridge by David and Melinda Bakara, veteran Bigfoot hunters who have both encountered the big guy. Every day, they hear personal Bigfoot sightings from visitors, many of whom have never confided their stories before, even to family.

Expedition Bigfoot has listening stations for Bigfoot howls and grunts, videos featuring people relating their personal experiences and various

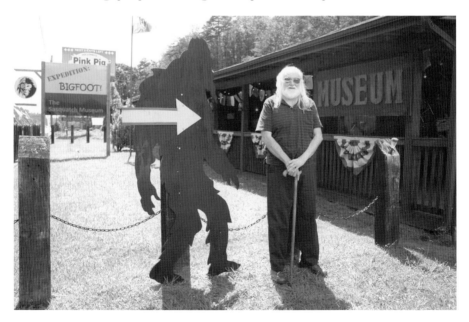

Expedition Bigfoot examines the history of the Sasquatch in America. This is a scale cutout of Bigfoot. I am six-foot-six, and Bigfoot is considerably taller. *Earline Miles.*

models of Bigfoot, including a full-sized monster. The best display is a large, dramatic diorama depicting a classic Sasquatch tale from 1924, when a group of Bigfoots launched a violent assault against miners in a remote Washington cabin. There are many casts of Bigfoot prints and one unique cast of a big Bigfoot butt. Apparently even Bigfoot has to occasionally take a load off.

A large display points out the sites of prominent Bigfoot activity across the country and the various names applied to regional Sasquatches. It is also explained what types of food to leave out if one desires to attract the friendly neighborhood Bigfoot (Zagnut bars are a favorite). Also, the gift shop is amazing.

Expedition Bigfoot, 1934 GA 575, Cherry Log, Georgia, 30522. 706-946-2601. expeditionbigfoot.mdom.mobi; expeditionbigfootblueridge@gmal.com. Closed on Tuesdays, otherwise open from 10:00 a.m. to 5:00 p.m.; in winter, call first.

CURIOUS PEOPLE STORIES

BIBB COUNTY: GRAND LARCENY SLEEPING

In late June 1942, a shipment of mail, including $31,617 in cash from Albany bound for the Federal Reserve Bank in Atlanta, entered the Macon Post Office. When the money turned up missing, authorities questioned Henry L. Chancey, a postal employee who had been the only person left alone with the money.

Chancey declared his innocence but told officers that he was a sleepwalker, a condition that developed while he served in the Marine Corps. He declared that he had no recollections of what transpired during these somnambulistic episodes and suggested that the money may have gone missing while he was in a trance.

Chancey went to sleep for detectives and in his "sleepwalking" state took them to a farm near Rutland, where the money was found buried in a hole. Authorities did not believe his story, for he was jailed by the Feds and arraigned before the United States commissioner. This story comes from *History of Macon, Georgia*.

CHATHAM COUNTY: DIVINE SLEEPING

In 1895, a woman fell into a trance "and upon her return to consciousness astonished all Yamacraw with a wonderful story of her visions while traveling in the 'great beyond,'" declared the *Savannah Morning News* on December 20, 1895.

The woman, Emma Jane Perrymore, explained that she had been ordained by "the good Lord" to have a regularly arranged schedule of trances, "every third Sunday for a certain length of time." In mid-December, "she went into a trance…and remained in an unconscious condition for fifteen hours. While in that condition she says she saw many strange things."

Following each trance, Perrymore would emerge to describe her "realms of empyreal day" to large crowds at Bryan Methodist Church. She missed an appointment to speak in late December, to the disappointment of the assembled multitude and Savannah newspapers, which disparaged her gift. Her next trance was scheduled for the third week in January.

BULLOCK COUNTY: BEWITCHED ZOMBIE

It was a strange autumn in eastern Georgia, for in late September and early October 1895, a thirteen-year-old girl named Florence Mincy had apparently been "entranced." The girl suddenly became "a raving maniac" and attacked and attempted to bite her parents. She was so violent that for ten days "it was necessary to keep her chained to a post to prevent her from doing herself and others harm," according to the *Bullock Times* of October 10, 1895.

Mincy ate not one morsel of food and lunged at anyone who approached her. When she started to calm down, she was released from her chain several times. In each instance, she started for the woods "as fast as she could run in the same direction, and at a certain place would fall" to the ground. At that spot, she lay helpless until carried back home.

These events were a great mystery until a "witch doctor" came along and announced that the girl had

The apparently bewitched Florence Mincy was kept chained to avoid harming herself or others. *Illustration by Sarah Haynes.*

been "bewitched." The parents were advised to "dig down at the place where the girl fell, where the secret would be revealed." They did and at a depth of two feet found "a small wad of hair." The witch doctor directed that the hair be burned. It was, and afterward, the girl was "as straight as ever."

MACON: FIRE IMMUNITY

The book *Modern American Spiritualism* by Emma Hardinge, published in New York in 1870, contains two remarkable examples of "fire immunity," the concept that spirits can bestow on their human vessels the ability to not be burned by fire. Both incidents occurred in Macon in 1860 and were initially presented in the *Christian Spiritualist*. They were witnessed by E. Hoffman and written up in April 1860 while he visited Mobile, Alabama.

When Mrs. Lovejoy of Cincinnati, Ohio, visited Macon, she was accompanied by her four-month-old daughter, who was considered "a remarkable medium." A number of people sat around her cradle until she was asleep, at which time they would ask questions of the spirits; the answers were spelled out either by raps or the cradle rocking. The seancers did not fear for the girl's well-being, because if she awoke she never cried but instead had a "happy smile over her sweet face, and the delight with which she crows along with the raps, to receive some pleasant influence from the power which is operating" through her.

As the adults crowded around the cradle on the evening of April 3, Hoffman asked, "Why did the Christians not give the signs which are promised to the believers in the last chapter of St. Mark?"

The rapper answered, "Because the Christians of this century were believers with their lips, but too many of their hearts were far from God," adding, "They would show what belief in the truth of Scripture

"During this horrifying ordeal, the child did not cry or whimper. Her nightdress was destroyed by the fire, but literally not a hair of her head had been harmed." *Illustration by Sarah Haynes.*

meant, through that baby, to-morrow, and prove that it was something more than lip service."

The next day, Hoffman, his wife, Mrs. Lovejoy and Mr. Newnan, an overseer from Mississippi, entered the parlor to commune with the sprits but were horrified to find the cradle "a mass of flames," probably ignited by sparks from the adjacent fireplace.

The ladies shrieked in terror while Mr. Newnan raced toward the inferno, snatched the infant from the fiery cradle and extinguished the flames by rolling it and its flaming nightdress on the floor matting. Hoffman grabbed a bucket of water from a servant, meant for the horses outside, and dumped it on the cradle, putting out the fire.

During this horrifying ordeal, the child did not cry or whimper. Her nightdress was destroyed by the fire, but literally not a hair of her head had been harmed, not "the least token of injury." Mrs. Lovejoy, the baby's mother, instantly retired to bed "in a painful condition of hysterical emotion," while the child cooed happily in the arms of her nurse, Cherry.

Hardinge described the second act of fire immunity: "April 4, 1860. In Macon, Georgia, a colored girl, who was an excellent physical medium, frequently exhibited the feat of thrusting her hand amongst the blazing pine logs, and removed it after some sixty seconds without the least injury. She always insisted, however, that she would only perform this feat when 'Cousin Joe,' whom she called her guardian spirit, was present, and bid her to do it."

STEPHENS COUNTY: FIERY DREAMING

Every night for a week, Toccoa resident Clete Burtch awoke from a dream of a blazing house. "I remember seeing trees and a house on fire, and I was just praying, 'please don't let that be us,'" he told the *Toccoa Record* on June 13, 2009.

Early on the morning of July 22, Burtch finished his late-shift job in Lavonia and started home, taking a different route than usual. Turning onto Brookhaven Circle at 2:00 a.m., he saw a burning house. "It was like déjà vu, it was the same house I saw in my dream."

Burtch turned into the driveway and started honking his horn. Inside the house, Faye Canup awoke and found the second floor ablaze. She screamed to waken her family, and Burtch assisted in the evacuation, rescuing two

children. No one was hurt as three fire companies arrived to fight the fire, which was the result of faulty wiring.

"I just thank the Lord" for Burtch and another man who stopped to help, Canup said.

Mad Gassers

Those interested in the paranormal may be familiar with the Mad Gasser of Mattoon, Illinois, an elusive phenomenon in 1944 in which gas was passed through the open windows of homes, rendering the inhabitants seriously ill for a time. After several weeks, the attacks ceased. Similar incidents occurred in other states and years, also lasting several weeks before ceasing as mysteriously as they had begun.

Mad Gasser of Columbus

Discovered from the files of the *Columbus Ledger* by Jan Doolittle Page are the antics of Georgia's first Mad Gasser, occurring long before any of the other better-known episodes of gassing. One attack per week was recorded for three consecutive weeks, and the motive in all appeared to be robbery, although only one was successful. Perhaps a World War I veteran, who had witnessed the terrible effect of gas attacks in France, decided to take advantage of a new technique to advance his criminal career, thankfully with a non-lethal agent.

The first attack occurred on First Avenue, where $300 worth of property was taken from Mr. D. Pow's house after he and his family were knocked out by a mysterious gas. The criminal next struck across the street, where L.O. Whitman, his wife and their seven-year-old son were sleeping. When the gas was pumped into a side window, the child woke up the mother, and all escaped to the porch, where they lost consciousness. This robbery attempt was unsuccessful, as was the last, also on First Avenue, the home of J.A. Whaley's family. A dog warned the family, which fled through the back door before all succumbed to the gas.

Mad Gasser of West Bainbridge

Scott Maruna wrote the seminal work on the subject, *The Mad Gasser of Mattoon*. Since its publication, he has received similar reports from six additional states, ranging in dates from the early 1930s to the early 1960s. A report from West Bainbridge, Georgia, "stood out," he wrote—a family story related by Lee Holliway, then a resident of Florida.

On December 4 or 5, 1944, Lee's family, the Deans, retired to the front porch following supper and "heard screams coming from down the street." Four men hurried toward the disturbance, where they learned that two women and several children eating supper "smelled something sweet that made them sick."

Word of a second attack arrived the following day. A sleeping woman "was awakened by a sweet smell that made her ill," Lee wrote. Concerned about her elderly father asleep in an adjoining room, she opened his door and found the "room was filled with the same odor." The woman helped her father out of bed and into the backyard, "where they both were sick."

By this time, the neighborhood was frightened, and Lee's grandmother said that "somebody had sprayed gas in through the window," often left open for fresh air. Reports of attacks sharply increased. In two other reported assaults, a woman, her granddaughter, an elderly couple and their son were exposed to the sweet, noxious odor.

At the Dean household, exterior doors and windows were closed and lights left burning through the night. Reports had the "gas being sprayed under doors, through broken windows, and through small openings around water and gas pipes, etc."

Six or seven attacks occurred that week. After supper on Friday, the family walked to a small traveling carnival. Mrs. Edna Dean developed a headache, and she and two other ladies started home for aspirin. Due to blackout conditions during World War II, there were no streetlights. As they passed a wooded area, they "heard someone walking behind them" and ran several blocks to the house, where they collapsed breathless on the steps. There, "all three heard footsteps and the screen door to the back porch opening and closing."

Frightened, they took refuge next door with neighbors until the rest of the family returned. The house was searched and found to be empty, and all went to bed. A visiting niece, Addie, slept on the couch in the living room. After being awakened by the creaking of the porch screen, which she dismissed as a cat, the girl fell asleep again, only to hear a noise outside the

window. As she looked, she saw "'a shadow' move across the window and she screamed." James Dean and a boarder named Norman Dollar ran outside but saw nothing.

That same night, a barking dog awakened a woman, who ventured onto her porch and saw "a man wearing dark clothes" run between her house and her neighbor's house. The brave woman grabbed a rifle and woke her neighbors, who said "there was gas in the house." They did not get sick— perhaps the Gasser was interrupted before his mission was completed.

Alarmed, the men of the community met at a church the next day and drew up a nightly patrol schedule. Most had guns, baseball bats or wooden walking canes reinforced with lead. Another night, as women of the Dean family left the home of their neighbors, the Allen family, they spotted "someone watching them from the bushes." The women "ran home screaming." Men searched the Allen house without result, but "later that night the gasser attacked the Allen's."

One night, three patrolling residents spotted a figure near a house occupied by a woman and her children. The men split up to confront the lurker from two directions. One of them caught the figure in a flashlight beam for a moment and said it had "strange looking eyes," describing the experience as "like

U.S. Senator Richard Russell was the "Great Dissenter" for objecting to the Warren Commission's conclusions about President Kennedy's assassination. His grave is located near Winder. *Jim Miles.*

looking into the eyes of the devil." The Gasser was thought to have escaped into the woods, but the witness insisted it had "disappeared into thin air."

The last incident occurred about December 14–15. The affected house was occupied by a mother, her two grown daughters and several children. One daughter was wheelchair-bound due to polio. When the gas was detected, the ladies shouted for help and had difficulty extricating the handicapped woman. Neighbor men responded, and one emerged saying the structure was "full of gas."

One victim said that the gas smelled "like the sickly sweetness of the banana shrub, a plant with exceptionally fragrant creamy yellow flowers." A woman said the gas made her vomit and gave her a headache for two days. No one experienced long-term effects.

Of the Gasser's origin, some thought it was a German gas attack, while others accused the American government of testing a new weapon. Others were convinced that it had been a paranormal phenomenon—a belief I share—along with a measure of mass hysteria. It erupted without warning and ended without trace. Unlike the Columbus gasser, this phenomenon seemed uninterested in plunder, just causing the upmost chaos.

SENATOR RICHARD RUSSELL AND THE JFK ASSASSINATION

In November 1963, Richard B. Russell was a powerful United States senator, having served in Congress for thirty years. The morning that President John F. Kennedy was assassinated, November 22, Senator Russell was in an anteroom of the Senate chamber, monitoring feeds from wire services.

One week later, on November 29, Russell received a telephone call from President Lyndon B. Johnson, an old Senate friend, who asked him to serve on the Warren Commission, established to investigate Kennedy's assassination. Russell flatly refused, only to receive a second call from Johnson five hours later informing the Georgian that he had been appointed to the commission and that the news had already been released. Despite his surprise and anger, Russell, who had spent his entire life in public service, reluctantly accepted the position.

As the controversial investigation started, Russell was experienced enough to suspect the motives of the FBI and CIA, the principal investigative agencies in the probe, and others who worked within the government.

At the initial meeting of the Warren Commission on December 5, 1963, Russell accused the FBI of leaking information to the press to force the commission to accept its ideas. He thought the FBI and other organizations were "planning to show Oswald" as the sole assassin, an "untenable position" to him.

During a session on January 27, 1964, Russell drew an admission from former CIA director Allen Dulles that the CIA and FBI "would never publicly admit that Oswald had worked for them, if that had indeed been true." Russell also believed that the theory of Oswald as the sole assassin advanced by the FBI had been reached hastily. "They have tried the case and reached a verdict on every aspect," Russell concluded.

One of the most discredited declarations of the Warren Commission concerned the "single bullet" or "magic bullet," which was claimed to have inflicted a non-lethal wound on Kennedy and then started an intricate journey that inflicted all the wounds of Texas governor John Connelly, who had been sitting beside the president. On September 16, Senator Russell, citing the testimony of Connelly; his wife, who sat beside him; and the Zapruder film, wrote, "I do not share the finding."

Russell also declared that a lack of evidence against Oswald precluded "the determination that Oswald and Oswald alone, without the knowledge, encouragement or assistance of any other person, planned and perpetrated the assassination." That statement was omitted from the final report of the commission.

On the following day, the commission met for the last time to present and discuss the official Warren Report. Russell advanced the same two reservations of the previous day, but this statement was excised from transcripts of the meeting. Later that day, Russell repeated his objections to President Johnson in a recorded conversation. Of the magic bullet, Russell, said, "I don't believe it." Johnson replied, "I don't either."

Russell was the first commission member to criticize its report, in the *Atlanta Journal Constitution* of September 29. Two years later, on November 20, 1966, the *AJC* called the senator "the great dissenter."

On June 6, 1968, Russell told Harold Weisberg, a noted investigator and journalist, that "we have not been told the truth about Oswald." Russell further stated that the FBI and other federal agencies had deceived the Warren Commission about Oswald's background and ballistics evidence.

On WSB-TV on February 11, 1970, Senator Russell said, "I have never believed that Oswald planned that altogether by himself…I think someone else worked with him." Russell believed that Oswald was the lone shooter

and fired three shots. Congressional committees have since upheld Russell's criticisms, citing the FBI and CIA for not adequately investigating the murder and failing to provide useful information to the Warren Commission.

For an exhaustive account of this story, read "Senator Richard Russell and the Great American Murder Mystery," an article written by Donald E. Wilkes Jr., professor of law at the University of Georgia Law School, in the November 19, 2003 edition of *Flagpole* magazine.

PSYCHICS HIT AND MISS

A 2005 psychic case from Georgia lends credence to the work of some psychics but reveals weaknesses with the efforts of others.

Thirty-year-old Greg Wallace measured five feet, eleven inches in height and weighed 250 pounds. His sister, Tonya, described him as a mild-mannered man who "couldn't see too well." At 4:30 a.m. on March 14, 2005, Greg left his mother's home in Ashburn, bound for his job at Tift Health Care, thirty miles away in Tifton. "He didn't make it to work that morning," said Mike Taylor, a criminal investigator with the Turner County Sheriff's Department.

Wallace's family promptly reported him missing, and officers soon located his 1984 Chevy Monte Carlo in a field bordering U.S. 41 between Tifton and Sycamore. "The hood was up and the keys were still in the ignition," Taylor said. It seemed as if Wallace had experienced car trouble and then disappeared. The Turner County Sheriff's Department brought in search dogs and the Georgia Bureau of Investigation provided a helicopter, but no trace of Wallace was found. Five days passed, and his family grew desperate.

On March 19, Andy Hester, chief deputy of the Turner County Sheriff's Department, revealed, somewhat cryptically, that Wallace's body had been found. "He was at the bottom of the pond and a female subject who had gone to the scene spotted the body when it surfaced," Taylor said. "There was no apparent evidence of foul play" nor visible injuries or wounds. Officials were waiting on the autopsy results.

By the following day, the rest of the story had emerged. The "female subject" was a psychic, Lynn Ann Maker, of Cedar Rapids, Iowa. Also, the body had surfaced mere feet from where Wallace's car had been found, an area thoroughly searched. Maker advertised her gifts as a "psychic detective"

in murder and missing person's cases. The Wallace family discovered her website while desperately seeking assistance in finding Greg.

Maker was confident that Wallace was underwater, stating, "I saw trees, but I was looking up, and I was trying to make sense of it…he was submerged in water, and he was under the water looking out at the trees, and I was him, in his body," Maker informed WALB television in Albany.

Maker's group had roamed across Turner County on March 19, but Lynn was repeatedly drawn to the pond. There she spoke into a tape recorder, saying, "I do get a feeling of passing on, of death." She was led to the site of Wallace's vehicle. "I kept feeling it was near the car."

Maker was drawn into the pond. "I walked four or five steps and in front of me I saw something come out of the water," she told Elliott Minor of the *Columbus Ledger-Enquirer*. "It was the top of his head. I didn't know for sure it was him. After his neck came out of the water, he turned. I could see it was him and I called 911."

Gary Rothwell, special agent in charge of the Georgia Bureau of Investigation (GBI) Perry office, downplayed the paranormal angle, saying, "It's just one of those freak things." Steve Mauldin, the Turner County Sheriff's Department chief investigator, allowed, "The psychic found the body floating and that's about all we can say."

Rumors circulated that Greg Wallace's neck had been broken and that a woman saw her husband kill him, but Turner County sheriff Randy Kendrick discounted the rumors.

The Wallace family believed that Greg was murdered, an idea reinforced by additional psychics who added their thoughts to the din. "I never believed it was a drowning," Geraldine Wallace, Greg's mother, said. "It's a murder, but you have to prove murder."

Psychic Jeffery Pierce of Lushing, Pennsylvania, arrived in November 2005 and made contacts in the spirit world. After forty hours of labor, Pierce seemed to back up the obvious evidence. He did not believe Wallace had been murdered. When he saw a picture of the deceased, "The first thing I sense was a lot of fear, almost terror," he said, although it was not caused by a human attacker, but rather by a large dog. Greg had stopped his car when it overheated, Pierce believes, and while going from house to house in search of water, a big dog had appeared. Fearful of the animal, Wallace ran and was pursued. In desperation, he plunged into the pond, unaware of its depth. Exhausted by the chase and unable to swim, Wallace had drowned.

"My conclusion is an accidental death," Pierce stated. "It was just a very bizarre act of God." After reaching these conclusions, Pierce discovered that Wallace had been unable to swim.

The case of Greg Wallace's death presents strong evidence of the effectiveness of psychics in helping the police locate a body, but some of the other psychic work did little credit to the field. One cannot help but wonder how much influence the beliefs of a grieving family have on psychics working a case, as well as vice versa.

A FEW GEORGIA GHOSTS

GHOSTS OF THE BLUE WILLOW INN

One of the grand homes in Social Circle today hosts the Blue Willow Inn. Constructed in the neoclassical style in 1907, it was the home of John and Bertha Upshaw, whose spirits may linger still. In 1991, Louis and Billie Van Dyke purchased the structure and fashioned their restaurant, which became known for its buffet serving southern country delicacies.

Ghostly activity often starts while an old structure is being renovated, but the ghosts at the Blue Willow Inn made their initial appearance after the restaurant opened. It started one evening after Louis turned off the lights and locked up. As he drove away, he noticed that the upstairs lights had somehow been turned back on. He stopped, reentered the restaurant, doused the lights and started to leave again. Looking back, he again found the windows glowing with electric illumination. Louis repeated his actions until the lights finally remained off. "It didn't scare me, it didn't frighten me," he told the *Covington News* for its October 13, 2010 edition.

Several years later, a forty-gallon pot of beans leaped from a worktable to the floor and then slid across the kitchen, remaining upright and not spilling a single bean. Once, while a prospective baker was demonstrating her skills, she observed two commercial roasting pans drop from the top of a convection oven to the floor and then slide across the floor and land on a shelf. The chef left. "We never heard from her again, and we knew there

The Blue Willow Inn in Social Circle is a celebrated restaurant serving traditional southern cooking. Ghostly former residents appear to chefs and diners alike. *Earline Miles.*

was no need to call her," Louis remembered. As another cook worked alone in the kitchen, he felt a hand firmly pressed against his back. A quick glance around confirmed that he was alone in the room.

The large windows of the inn are covered with shutters that can be opened for views of the beautifully landscaped grounds or shut against the bright sun. A couple still eating at closing time were startled when the shutters loudly opened and closed on their own accord. "They decided they didn't want to stay for dessert," Louis quipped.

On one calm day, a chandelier started spinning so violently that the support bolts fell out, leaving only the electrical cord holding the light in the ceiling.

Beckie Hilsman, a ten-year employee, was cleaning the expansive front porch where guests relax in rocking chairs. She stopped when one rocker started moving back and forth by itself. Then, one after another, the other rockers joined the activity. Across Georgia, ghosts have often demonstrated a fondness for occupying rocking chairs.

In the autumn of 2009, two children ventured upstairs to the Blue Room, which was decorated for Christmas. The siblings, a sister and brother, scampered back downstairs to report that the "lady in the pink dress" hovered above them, Hilsman said.

Several teams of psychic investigators have searched the restaurant for evidence of ghosts. Hilsman, who accompanied Haunt Analysts, heard a child's voice calling out for her mother at 2:30 a.m. One of the investigators spotted a man attired in nineteenth-century clothing standing at the podium where customers are welcomed into the restaurant.

EVPs captured in an upstairs dining room seemed to answer questions. To "How many of you are there here?" a voice seemed to reply, "Don't piss me off." To "Who is the male with us?" came "Get out." "Is your name Bertha?" elicited, "He heard me." "What are you doing here?" brought "I cannot believe you." Finally, in reply to "Is your name John?" came "Yes Johnny Harper."

Some believe the ghosts are those of the original owners of the house, John and Bertha Upshaw. To placate the spirits, employees often speak to the former occupants. Hilsman addresses Bertha. "I always tell her good night and thank her," she said. "She's part of us. She gives the place so much character."

As for Louis, "I do not believe in ghosts," he said. "Never have. However, something's going on from time to time, but I don't want to admit it's a ghost. But there is something going on." You may want to read *The Blue Willow Inn Bible of Southern Cooking*, authored by the Van Dykes.

Unfortunately, Louis Van Dyke died suddenly on November 24, 2010, at age sixty-three. Billie now manages the restaurant, which is located at 294 Cherokee Road, Social Circle, Georgia (770-464-2131; http://bluewillowinn.com).

GHOST OF MARY VIRGINIA HARRISON

Mary Virginia Harrison was considered an exotic and fun-loving woman with a dark side shown by her severe mood swings. She was born in 1925 to Milledgeville residents Benjamin and Gussy Harrison. "She was really talented," said Bob Wilson, professor of history and official historian of Georgia College and State University, "but screwed up."

She attended Georgia State College for Women, where one friend was noted southern writer Flannery O'Connor. During her college years, Harrison worked on the staff of the school newspaper, *The Corinthian*, was president of the Literary Guild, a member of Alpha Psi Omega and the Allegri Club and was involved in many other activities. "She was beautiful:

dark hair, brown eyes," said Wilson. "For her, life without boys and men was just insupportable; it was just like one after another. And she was the ultimate flirt; she was the southern belle of all time."

Harrison was married to John A. Mills for five years and then to Roy Russell Sr. from 1959 until his death in 1974. With his demise, Harrison moved in with her mother in the family home at 434 West Hancock Street. One day in 1979, Harrison's mother entertained a couple, asking if they wanted a pistol she had kept to shoot snakes on the grounds. At her age, she no longer had use for it.

"She left the gun on the table," Wilson said, "and Mary Virginia on this impulse—and there was a maid in the house who saw this—grabbed the gun and went running through the house, down the back steps, out to this little magnolia tree out back, and put the gun to her head and shot herself." She died in the hospital.

The Harrison House now belongs to Georgia College and houses the Office of Institutional Research. On the mantel in one room sits a photograph of Mary Virginia and one of her possessions: a single shoe.

Wilson had heard rumors that the house was haunted. Lights flickered and doors closed for no reason. In 2001, he took a year's sabbatical for

Socialite Mary Virginia Harrison haunts her former Milledgeville home, where she killed herself. *Earline Miles.*

research and moved his office into a former bedroom of the Harrison House. "I was putting my books on a shelf around 11:00 p.m. when all three doors of the room shut at the same time," Wilson said. *Boom! Boom! Boom!* "I looked to the window to see if a breeze was the cause, but the windows weren't open, so I introduced myself." The remainder of his tenure there was uneventful.

"I never had anything else weird happen until I was packing to move next door to the Humber-White House," Wilson continued. "I sat down to take a break, and this perfume just permeates the room, out of nowhere. So I went out into the hallway to try and see if there were somebody here. And then it was gone."

In his new office at the Humber-White House, once owned by Harrison, Wilson detected the same perfume as in the Harrison House. He was subsequently informed that Harrison was a perfume connoisseur and particularly loved Chanel No. 5 and White Shoulders.

The Old Haunted Washington County Jail

Essie English was a sixteen-year-old girl living upstairs in the family portion of the Washington County Jail in 1901, happily engaged to be married. One Saturday morning, when she stood too close to a fireplace, her dress caught fire, and she was horribly burned. Newspaper accounts record the frantic but useless efforts of her father and brother to extinguish the fire. After two weeks of excruciating pain, English died. She lies in an unmarked grave in a cemetery behind the jail, so she doesn't have a long commute to haunt the building 116 years after her death.

The Washington County Historical Society is headquartered in the Old Jail Museum in Sandersville. For years, workers at the museum have experienced paranormal events. "I went upstairs to Essie's room," stated Clara Brookins, "and the Victrola is by the door and I saw it was spinning, and it was not air conditioning—no windows up there, no draft, so I stopped it. I continued to look around the room, and I turned around to look at it and it started spinning again."

"We have different things happening," said Loretta Cato, chairman of the Genealogy Department, "that were not normal" and were witnessed by many who "have felt these spirits." Workers and visitors have felt "a pressure…you feel like there's something back behind you or around you

A sixteen-year-old girl was accidentally burned to death at the old Washington County Jail. Her ghost has often amused workers at the museum. *Earline Miles.*

and it's an awesome feeling." Unfortunately, Cato said, Essie "didn't live here long enough to really enjoy life."

To investigate these events, a ten-member team from Lost Souls Paranormal in South Carolina arrived on August 11 to spend the night and conduct a scientific search for evidence of the supernatural. TV station WMAZ CBS Macon tagged along for the experience. The equipment utilized included video cameras, audio recorders, motion sensors and K-2 meters, which measure electromagnetic fields. In short, they were loaded for Casper. Three rooms within the jail were investigated: Essie's Room, Miss Elizabeth's Room and a cell used for female inmates.

In Essie's Room, the motion detector went off multiple times, which might have indicated the presence of a spirit or merely movements of the living, investigators frankly admitted. When Lost Souls placed flashlights in Essie's room and asked, "Essie, are you happy here?" one flashlight activated. They asked Essie if she would answer additional questions, and "the light immediately went off." Other questions were posed, and Essie would answer via the flashlights, "which would come on in different brightness." In the cell, investigator Nicolle Gredzky felt a pull on her ponytail. "It was definitely a weird sensation," she said.

Within a month, Lost Souls Paranormal submitted its report to the Washington County Historical Society detailing what its members saw, heard and experienced during their investigation. The organization concluded that there was some evidence of paranormal activity, particularly a taped EVP and a fast-moving orb caught on camera.

Staff were glad to have their experiences confirmed. Cato said that future tours of the jail would include information about the supernatural—and why not, as the first news report of Essie increased visitation to the jail by 33 percent. Just imagine what a full-bodied apparition could draw.

For a Halloween feature in 2012, WMGT NBC Macon visited the Old Jail Museum. "I think you would classify me more as a skeptic," said Marilyn Daniel, Cato's assistant, "but I have seen strange things and heard strange things in this building that have caused me to take second thoughts. The front door opens and closes a lot…and no one is there. The toilet occasionally will flush."

Reporter Andrew Reeser invited Darkside Syndicate, ghost hunters from Milner, to investigate the historic building. Will Aymerich, lead investigator, was excited by the challenge. "I'm going to count to ten," Aymerich addressed Essie, "and then if you don't communicate with us, we're going to move to the other room."

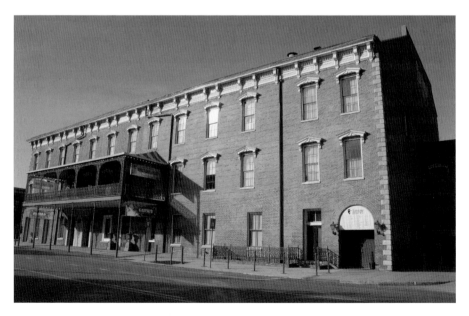

Many famous thespians performed at the Springer Opera House in Columbus, thought to be haunted by famed Shakespearean actor Edwin Booth. *Earline Miles.*

At that point, an audio recorder captured the words, "That's quick," apparently indicating that she had difficulty complying in such a short span of time. Another audio recording revealed footsteps climbing the stairs when no one was there.

According to Taylor Hembree, in an article titled "Essie English: Death and Hauntings" that appeared in *Sandersville Scene* in September–October 2016, the light in Essie's room burned after closing hours; doors, locked and even wired shut, often opened; and books spontaneously fell to the floor. After the staircase had been refinished, a bloodstain from Essie's accident remained, "engrained deep within the wood,"

One night, firemen saw lights in the jail turning on and off. Museum volunteer Kayla Jackson, a policeman and a fireman investigated, finding no one within the structure. When they reached the top of the landing, an electric candle in a window abruptly fell off and landed on the stairs at the bloodstain.

Essie knows when she's being investigated. Although the alarm is turned off, it starts announcing that the alarm will sound in sixty seconds, thirty seconds and so on and must be turned off again each time. During one investigation, it started to announce minutes rather than seconds, which the alarm company stated was impossible. Jail staff finally had to unscrew all the connections to make the system remain quiet.

Old Jail Museum, 129 Jones Street, Sandersville, Georgia, 31082; 478-552-6965; genealogyresearch@att.net; http://wacohistorical.org. Open Tuesday, Thursday and Friday from 2:00 to 5:00 p.m., Saturday from 10:00 a.m. to 3:00 p.m. or by appointment.

Ghosts of Thespians Past at the Springer Opera House in Columbus

Constructed in 1851, the Springer is a grand, three-story brick structure. Across the stage trod Tom Thumb, John L. Sullivan, Ethel Barrymore, Irving Berlin, Buffalo Bill Cody, William Jennings Bryan, Will Rogers, Oscar Wilde, Booker T. Washington and many others, including the notable Edwin Booth, brother of John Wilkes Booth, Abraham Lincoln's assassin. In the 1850s, both brothers performed Shakespeare in Columbus, and on February 15, 1876, Edwin performed *Hamlet* here.

Abandoned for many years, the theater was nearly demolished in 1963. It was saved and renovated and is now thought to be thoroughly haunted. The laughter of children is heard, green lights glow in the basement dressing rooms and on the third floor, scraping sounds are heard, followed by a foul smell. Props are regularly moved, and workers hear music performed by an invisible orchestra. Rooms are rearranged and doors slam.

In 1996, local artists were invited into the beautiful structure to draw inspiration for paintings, which were sold at a fundraiser. That August, Jill Philip and her two children visited the notoriously haunted third-story costume room. The kids played while Jill took photos, and when the film was developed several days later, daughter Chancey asked, "Mama, what's this? It looks like a face." One photo held an image that resembled a child peering out of a room. It might be a girl's face, pale with dark spots for eyes and mouth.

Artist Geri Davis had visited the costume room earlier. "When I got in there, I wanted to get out of the room," she said, believing she was not alone. Before leaving, she opened a curtain and took a picture of the window. On one portion of the photo was the faint image of a man. She re-created the image in a watercolor titled *To Be or Not to Be*. An eerie event occurred while Geri executed the work. At 1:30 a.m., a palette lid that lay flat on a table jumped off and hit the floor with a loud *bang*!

While on the third floor, one artist looked into a mirror and for a moment saw a different face peering back at her. "Many nights I'm here alone and I'll hear a door slam and footsteps," said Springer employee Amy Bishop. "It's happened to me more than once." She has sensed the spirits of people who were not visible, and in February 1994, as she played piano during Hollywood Cabaret, she spotted an unauthorized addition to the stage show. The figure appeared only from the waist up, clad in a Victorian dress with a brooch. The interloper suddenly vanished.

Ralph Wimberly is a costumer who has repeatedly locked up a tidy costume room at night and the following morning found articles cast casually about the space. Staff members unable to locate a particular piece in the costume room have learned to speak its name, and the article will be found in the next place they look.

Many people associated with the Springer believe that Edwin Booth is irked because the opera house never performs his favorite play, *Hamlet*. Some refuse to utter its name because strange things often happen afterward. Booth's spirit is encountered in the costume room, onstage, among the box seats and in the lobby, where his portrait hangs.

Ghosts of the Windsor

In the late nineteenth century, wealthy citizens from across northeastern America escaped the frigid winters by taking up residence in southern Georgia, from the Golden Isles to Thomasville's famous hunting plantations. To capture some of that trade, in 1892 the Windsor Hotel was erected in downtown Americus. The block-sized, five-story structure, constructed of brick manufactured only blocks away, contained one hundred rooms and a variety of architectural styles and features, including a three-story open atrium lobby and a fifth-floor ballroom, all designed by Atlantan G.L. Norman. It cost $150,000.

Guests of the Windsor included boxing great John L. Sullivan, three-time Democratic presidential candidate William Jennings Bryan, noted socialist Eugene V. Debs and Franklin D. Roosevelt, then New York governor and later a U.S. president elected four times. It is believed that a famous gangster— accounts claim either Al Capone or John Dillinger—once occupied the Bridal Suite, with bodyguards at the bottom of the private staircase.

As the result of a national depression, the Windsor declared bankruptcy in 1899. Charles A. Fricker, a local jeweler who had crafted all the silver used

The restored 1892 Windsor Hotel in Americus is haunted by a maid, her daughter and an elevator operator. *Earline Miles.*

in the grand hotel, purchased it at auction for $40,000. For another $75,000, he added electric lights, a new elevator, steam heat and telephones, but the glory days of the hotel were past. In 1974, when the hotel was being used solely as apartments, it closed.

In 1978, the Windsor was donated to the City of Americus, which saw its options as demolition for parking or restoration. The populace demanded restoration, and nearly $6 million was raised through private and public contributions. The Windsor reopened with fifty-three rooms on September 20, 1991. Each room is unique and features twelve-foot ceilings. Guests since have included local residents Jimmy and Rosalynn Carter, Jessica Tandy and Hume Cronyn while filming *To Dance with the White Dog*, Pat Boone and the McGuire sisters.

Ida Robinson was manager of the Windsor's dining room for a number of years. Did she believe in the ghost stories? Oh, yes. "I wouldn't stay at night at the hotel by myself," Robinson stated. "I don't think you can pay me to stay in the dining room alone at night."

What inspired such a fear of being alone in the historic building? It was an encounter on the third-floor hallway, which is notoriously haunted. "One night I came up to do a room service and I was entering down the hall with my tray, and I was walking, minding my own business, and there was somebody that hopped by me and kept running. I said, 'Oh, my god.'" What she saw was the ghost of a little girl sprinting down the hall.

Robinson fully subscribed to the idea that the enormous brick hotel is haunted by a maid and her young daughter, who were killed, perhaps by being thrown down the elevator shaft in the early 1900s. "I am very much convinced," she declared. The child is often seen running down the hall, laughing innocently.

The dining room was just as haunted. One day, an empty salad plate was seen being filled with greens by a phantom wielding an equally invisible utensil. "We all heard the tongs *click*, but there was no one there."

On a different occasion, all the employees were working on one side of the room when a stereo on the opposite side abruptly turned itself on. Pots and pans moved by themselves and fell off hooks, and plates and glasses were thrown from shelves to shatter on the floor. "We always joke that when a glass breaks, the little girl or her mom are mad."

One morning in 2003 at 5:00 a.m., Robinson headed to the Windsor's basement to fetch materials for preparing breakfast. As she opened the door, she was confronted by a face staring at her from the top of an enormous refrigerator. "I won't go into the basement alone anymore."

A man who once operated the elevator for many years is a third resident spirit. Floyd Lowery was his name, perhaps the most beloved employee at the Windsor, spending more than forty years as doorman and elevator operator. Known for his unfailing hospitality, he greeted every guest by name. During the 1991 renovations, Lowery's old uniform was discovered in a wall safe, perhaps inspiring his spirit to resume his service here. Although the hotel bar has been named for Lowery, everyone knew that the man was a lifelong teetotaler.

Lowery actually made a somewhat "physical" appearance, also on the third floor, which seems to be a gathering place for the building's spooks. "They said they saw it," said Christiane Grune with the Windsor's public relations department. "They saw his ghost, his silhouette on the third floor, and that's something new because we had never heard anyone say they saw Floyd Lowery." Grume believes that "probably people that love the Windsor…have worked here before such as the housekeeper and Floyd, and they just don't want to leave."

"Guests and employees have reported seeing and hearing the voice of a little girl on the third floor of the hotel," said owner Sharad Patel. "She runs laughing down the hallway at night." He also confirmed that "kitchen staff has reported seeing pots and pans flying at night and being mysteriously misplaced," and the radio has "turned on and off by itself." A writer friend of his from Washington, D.C., spent a week at the Windsor and believes she felt "the spirit of the ghost."

Grune said that guests travel long distances just to stay in the haunted Windsor. "They asked to be put in the third floor because that's where the ghost walks around, the little girl," she said. "They know nothing's going to happen, nothing bad." Grune emphasized that theirs "are friendly ghosts— very, very friendly ghosts. They love this place, and this is where they want to stay forever and who wouldn't?"

On August 13, 2006, six members of Big Bend Ghost Trackers (BBGT) arrived for an investigation that lasted from 8:00 p.m. until 11:00 p.m., conducted in the company of ten witnesses, members of the media and hotel staff. "I showed them several different parts of the hotel," Grune said. The team worked in the basement, staircases, attic, kitchen, guest rooms and dining rooms.

The Trackers' equipment included thermal scanners that detect sudden changes in temperature; electromagnetic field detectors that can sense the presence of a spirit; motion detectors; handheld digital and analog sound recorders for recording ghostly comments (spirit voices seem to operate on

a different level than the living); and digital and film cameras, the latter loaded with color, black-and-white and infrared film. Of a less scientific nature, the team employed "sensitives," people who receive impressions from meditation.

The investigative team expended most of its efforts on the third floor. Two members, Betty Davis and Lisa, entered "states of meditation and channeling" in order to contact the female spirits. To attract the attention of the girl, Betty started singing in a childlike voice "A Tisket a Tasket," popular at the end of the nineteenth century and probably known to the child. According to a Trackers account written by Davis, she "suddenly felt a cool breeze on her right side and the digital thermometer displayed a sudden 6 degree drop in temperature. While continuing to sing she was clearly able to sense the presence of a young girl."

Shortly afterward, a digital camera recorded three orbs that seemed to bounce or skip down the hall. Betty received the names "Sallie" and "Theresa," presumably the female spirits identifying themselves.

Lights had been unscrewed for the purpose of filming, and when the female spirit was present, one bulb turned itself on for a time before winking out. On the third floor, team members heard a woman's voice and a child crying.

Of the many photos taken by team members and later analyzed, several revealed anomalies. One photo captured "a small fog-like snake moving down one of the hallways." Several photos showed a white misty haze in the hotel. There were also two fluctuations on the EMP meter and temperature spikes of six and eight degrees, normally hardly worth noticing, but they occurred in concert with other phenomena.

After examining all the evidence gathered at the Windsor, the BBGT declared the building to be a certified haunted hotel. Employee Robinson was satisfied to find her beliefs and accounts validated, but that failed to comfort her. "I won't be going anywhere alone now," she confided. "I'm still scared."

Grune, the public relations person, described the findings as "something exciting more than scary," and she was intrigued by the marketing prospects of the phenomenon, saying, "A lot of people are into that kind of thing." The investigation received extensive television and newspaper coverage, and the Windsor's website now includes a ghost section.

Windsor Hotel, 125 West Lamar Street, Americus, Georgia, 31709; (229) 924-1555; http://www.windsor-americus.com.

Don't Mention the Ghost

On December 10, 1978, *Atlanta Journal Constitution* writer Charles Salter found a ghost property whose owner wanted to remain anonymous, so the destination was simply described as an antebellum house on a country road in North Georgia.

The woman of the house, dubbed Mrs. Jones, met Salter outside her home and told the story in a neighbors' residence. Her house haint had a serious thing about being mentioned within its abode. "She does not like to be mentioned in the house," the lady said. "If you do, something will happen every time." She felt the family was on "good terms, pleasant terms" with the spirit and would rather not endanger that relationship. Would you go out of your way to provoke a supernatural entity?

The ghost had revealed itself soon after they occupied the house twenty years earlier. One day, when Mrs. Jones was absent, her husband was reading in their upstairs bedroom. His peace was disrupted by the sound of the back door opening and someone entering the house. Alarmed, he ran downstairs to find the door open, but a search revealed no one. Upon returning to his room, the same sounds were heard. "The heck with it," he decided, returning to his book. "They'll just have to get me." When his wife got home, he told her, "You've got a ghost."

Other incidents occurred. One day a picture fell from a wall of the living room, but the glass did not break and the hanging wire remained intact. When a pet mouse was purchased in Atlanta as a birthday gift for their youngest daughter, the creature was secreted in the locked guest room. "The morning of her birthday, I went downstairs and found the guest room door ajar," Mrs. Jones stated. "The key was still lying on top of the door. I went inside, and the cage door was still closed"—but it was empty. Little Margaret the mouse was gone, apparently teleported from its cage, room and house, perhaps as a playmate for the ghost.

A number of people who visited the house for the first time said, "Oh, it's so cold in here." As an older daughter prepared for a date, she heard "loud noises, someone slamming and blamming in a bedroom." She checked that room, found no problem and walked into a bathroom. When she attempted to leave, the door refused to budge. She was forced to open the bathroom window and yell to her date, "Come up here. I can't get the bathroom door open."

Mrs. Jones learned the ghost was a woman during a Christmas season. The family turned off the holiday lights one evening to visit friends, returning

later to find the lights blazing brightly. "We never left the tree lights on when we weren't home. I saw a person standing by the Christmas tree in the window. The form was gray. The dress was like ones worn in the middle 1800s. I never saw her face though." The apparition suddenly vanished.

One day, Mrs. Jones felt she was not alone in a room and glimpsed fleeting shadows in halls and doorways. Both Mrs. Jones and her sister were alone in a room occupied by three cats. Suddenly, they realized that all the felines were tracking an unseen presence. "The cats' eyes and heads slowly moved back and forth," said the sister.

The oldest daughter returned home one night to hear a record playing very slowly. "She walked into the room and saw the record player was not plugged into the outlet. But the turntable, without a record on it, was turning round and round, and she heard the music." The experience terrified her.

The kitchen sink had a mirror over it, and one night, the teenage daughter and a friend were there when the girl made "fun of the ghost." The daughter cautioned her, saying, "Don't say that." When the friend looked up at the mirror, she "screamed and ran into the yard, shouting, 'I'm not going back in your house. There was a terrible face in the mirror.'"

That was not the spirit's first manifestation. When Mrs. Jones's youngest was a baby, she heard her screaming and ran into her bedroom to find the child pointing at the wall mirror. "I looked into the mirror. The image was horrible. It was just a head with big eyes and the mouth smiling. Nothing on the bed was reflected that could have been this thing in the mirror." She removed the mirror.

The mirror image had been horrible enough, but the ghost next committed an act of violence. When one of her daughter's girlfriends was on the stairs, she "felt two hands on her back and it felt like someone pushed her down the steps," leaving her bruised.

One morning at 6:30 a.m., Mrs. Jones was in the kitchen with a cup of coffee and a cigarette when she heard splashing, as if liquids were being dropped from a height of several feet. Looking around, she saw no water falling, but she found a puddle on the floor beside her where "thin, brownish liquid was forming, getting bigger, then moving toward my chair." "My three cats heard it and looked at it too. One of them ran over to the puddle, smelled it and bowed up."

Mrs. Jones used paper towels to wipe up the liquid and then smelled it. She described it as "like a tom cat's urine. A very strong odor." She considered sending it to parapsychologists at Duke University but didn't, as "something seemed to say, 'Don't do it.'" She listened to her instincts and simply threw it away.

Waffle House Ghost

Sometimes, a ghost story finds you. We were at our favorite Waffle House in Warner Robins one night in the spring of 2015. We were the only patrons for most of our visit, and there were three very attentive young workers going about their business. One girl finished mopping the floor and said she did not want to use the back door. We felt a story coming and asked why. "There are noises back there," one said. "Noises that shouldn't be there. Spooky sounds. None of us like going back there." The others concurred.

"Yeah, and there's something in the bathrooms," another offered. "I was back there cleaning one day, and the hand dryers in both bathrooms went off at the same time. I only clean them with the doors open."

"What if you have to use the bathroom?" Earline asked.

"I can hold it till my shift's over. Or there's a convenience store nearby. They understand the situation here."

"We keep the lids for takeout drinks stacked on top of the big refrigerator," said the cook. "One time I was working, and for no reason at all, they all fell over. That's happened several times since, and now I stack them very carefully. They still fall over."

Few connect Waffle House with ghosts, but employees at one Warner Robins restaurant described a variety of paranormal phenomena. *Earline Miles.*

One waitress turned to another and said, "You remember that night we were working here together, and a plate fell off a counter? I said, 'Did you do that?' and you said, 'No, I did not.' And I said, 'Let's pretend you did it,' and you said, 'OK, I'll believe it if you do.'"

On another slow night, one of the workers was fooling around with a camera. He looked through it, suddenly looked up and then checked the viewfinder again. "Girl," he said slowly, "there's a dude standing behind you." The woman quickly whirled around but found no one there. "I saw him through the viewfinder, but I couldn't see him when I looked with my eyes. I swear I saw him twice through the camera."

"Did you take a picture?"

"No."

"Good. Before you spoke, I swear I felt someone breathing on my neck."

On a different occasion, another employee saw a phantom standing behind one of her coworkers.

While we ate, one waitress started back to clean the bathrooms, teased by the other two. "I'm not afraid," she replied. "I know my Bible verses." While she cleaned, the other waitress slipped back and suddenly slapped the wall. The cleaner came unglued for a moment and then turned to us and asked, "She did that, and y'all didn't do nothing?"

"I'm not going back there!" I said.

"Well, I was praying for you," Earline said.

"You a good church lady," the employee replied.

I have gathered many weird stories from Waffle Houses across the region, but this was my first ghost tale.

Historic Exploding Mountain Ghost

One night, a number of people were walking home from church in the ridges of Walker County when they found their way blocked by a frightening apparition one hundred yards ahead. It was a man, whose "eyes looked like two great balls of fire, teeth as white as snow, hair almost trailing on the ground," reported the *Denton (MD) Journal* of October 5, 1889.

Hesitantly, they continued forward, only to see that "it appeared as a woman dressed in white and of giant size." The churchgoers conferred on whether a tactical withdrawal was wise but continued for fear of ridicule from others. As they approached, they were surprised to see the ghost retreat,

A shape-changing apparition in the mountains of Walker County appeared to explode when witnesses approached it. *Illustration by Sarah Haynes.*

although "all the time appeared larger." At a distance of two hundred yards, it very suddenly "appeared to explode and throw its fragments in every direction, resembling the explosion of a coal oil lamp," causing the witnesses to scatter for home, each "scared within an inch of his life."

Atlanta's TV Ghost

In the predawn darkness of August 11, 2016, Katie Muse, a digital producer for FOX 5 television, pulled into the parking lot. She turned off the car, placed her phone in her purse and looked to one side, where "I saw what looked like a man and he had some type of weapon, like a saber, and he was just slowly walking toward me." Muse looked away for a moment, and when she looked again, the figure had disappeared.

She immediately texted two producers: "I think I just saw a ghost in the parking lot." One producer promptly asked if she had taken a photo of it. "No, I freaked out and it was gone."

When Muse described her experience in the newsroom, other employees said, "She saw the FOX 5 ghost," which she had never heard of before. Stories of a ghostly apparition wearing a Confederate uniform strolling across the property, on Briarcliff Road near Emory University, "were legendry," she was told, and had circulated for years. In 1864, during the Civil War's Atlanta Campaign, the land had been an entrenched campground for Confederate troops and was occupied by Federal soldiers on July 20, during the Battle of Peachtree Creek.

"When I saw it, I definitely knew that I saw something," Muse stated, and after she heard the stories from other station personnel, she agreed that she had seen the same phenomenon.

Paul Milliken, who reported the strange story for a Halloween story several months later, said that "so many before her had said the exact same words." The segment, "Infamous FOX 5 Ghost," addressed "the latest in a long list of employees who have reported supernatural encounters right here at our station."

Jeff Hill, chief meteorologist, arrived at the station early one morning to do *Good Day, Atlanta*. As he turned a corner, "I just saw this image go by…and it looked like a soldier." "Out of the corner of my eye, I noticed somebody walk by the entrance to the door," added Craig Bitler, facilities manager. When he heard no sound, he walked outside to check and found nobody. He thought "it looked like a soldier," which was "something here you don't expect."

FOX 5 invited two ghost investigators from Paranormal Georgia Investigation, Heather Dobson and Cline Brownlee, for a paranormal survey of the facility. As Dobson asked if someone was present, the battery of the station camera abruptly ceased working.

Civil War Show Stories

I have often attended the Chickamauga Civil War Show in Dalton each February and the Marietta Civil War Show in August. I sell books and chat with those who have the same historical interests. Since my three Georgia Civil War ghost books came out in 2013, a number of people will stop, pick one up and page through it and then look at me and say, "Do you really believe this stuff?" or "Have you ever seen a ghost?" or simply, "I've got a story for you." I always settle back because I know a good tale is coming.

Traci told me one:

> *I live in a Cobb County development constructed along a line of Confederate earthworks. Behind my house, you can still see the depression from a long trench. Many times when I go out on my deck or look out a back window, I see a Confederate soldier—just one, but I think it's the same one—standing in the trench, looking back at me. On several occasions I have waved at him, and even spoken to him, but he just keeps on staring, never moving an inch or speaking a word.*
>
> *I've taken pictures, but what I get is the trench and the trees behind it, and a strange distortion where the soldier is standing. He's always in the exact same position, so I think he must have been killed while standing sentry duty. Apparently, he doesn't know the war is over, so he keeps standing his duty post. I have considered having a psychic out to reason with this soldier, but I kind of like the feeling that he's back there, keeping watch. I don't find it creepy at all, but rather comforting.*

Renee and her husband operate the History Store in Fort Oglethorpe near the extremely haunted Chickamauga battlefield. She told me that one night, her husband was leading a party across the battlefield when he saw something running toward him. The entity proceeded to run *through* him, turning his entire body ice cold. He looked at the people behind him, but they had experienced nothing; the phenomenon had not affected them. He avoided that part of the battlefield for some time.

Tim works a lot at Tunnel Hill reenactments and ghost tours, and he told me another source for the prevalent ghost activity there:

> *A century ago, there was a man and his wagon, wanting to take his produce to market in Dalton. He waited until a train passed through the tunnel*

Left: Cobb County resident Traci described the ghost of a Confederate soldier who stands duty in an old Civil War trench behind her home. *Jim Miles.*

Below: Chickamauga is a highly haunted battlefield. A guide was taking a tour across the grounds when a sprit ran *through* him, leaving his body ice cold. *Jim Miles.*

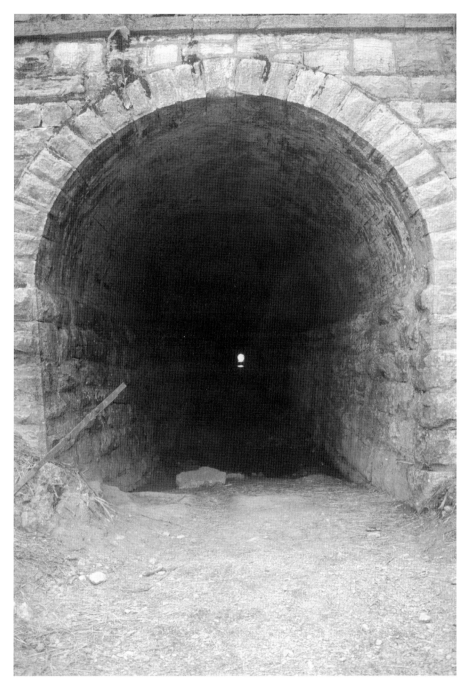

The old railroad tube at Tunnel Hill is haunted by Civil War soldiers and a wagoneer who tragically misjudged a train schedule. *Jim Miles.*

and thought there wouldn't be another for a while, so he started through the tunnel. Unfortunately, he missed the signal which indicated that a second train was closely following the first.

He was deep inside the tunnel, beyond the curve, when the second train thundered through the mountain. The man wasn't able to exit the tunnel at the other end, and the train hit him full speed. He and the animal were killed instantly and the wagon crushed to pieces. His ghost is seen sometimes still trying to complete his journey.

When we take groups of people through the tunnel, we tell them to look deeply into each alcove, where people walking through the tunnel could be protected if a train came along. Sometimes, they will feel creepy, and once in a while they can see what looks like a soldier staring back at them. But mostly, people will take a flash photograph of the alcove and see nothing. When we're back in the sunlight, they will review their pictures and scream, because the camera caught what was actually hidden in that alcove.

ALIENS AND ABDUCTIONS

*F*or some unknown reason, UFO activity in Georgia seems down while alien appearances and abductions are up, an interesting and troubling trend.

CONNIE'S SAGA

In their 2011 book, *Aliens in the Backyard: UFOs, Abductions, and Synchronicity*, and their 2017 book, *Beyond Strange: True Tales of Alien Encounters and Paranormal Mysteries*, Rob and Trish MacGregor described the experiences of Connie Cannon, a longtime alien abductee.

Connie, a nurse, remembered three separate abductions from her childhood. When she was four years old, she lived near the Governor's Mansion in Montgomery, Alabama. One day, when she was pretending to go to school, she encountered a seven-foot-tall, "strangely shaped" entity, apparently an albino with long blond hair. It was covered by a full-length "silver-gray garment." Connie started walking away, but it wrapped a long, thin arm around her, and she found herself rising into the air on a beam that was wide at the bottom but narrow at the top. She looked down to see her books strewn across the lawn.

An unknown woman took her home, walked her to the door and "then just seemed to vanish" without saying a word. That night, after she became

violently ill, she told her parents of the odd experience, but they dismissed it as childish imagination.

At age seven, Connie was coloring a book on her bed when suddenly the "long thin arm" grabbed her, and they glided up again "on a beam of light" while she heard "a high pitched steady sound." She had no further memories of the incident but again became very sick. Connie's sister remembered "Grays being in our shared bedroom," a topic they only discussed as adults.

At nine, Connie was at her grandparents' house in Atlanta, picking blackberries with other children. Suddenly, all of them felt "the ground shifting under us." All she remembered was falling ill afterward. Connie had a lifelong series of encounters, most of them with frightening aliens but also some with "benevolent beings that guided her."

Perhaps the oddest event occurred on November 9, 1981, when Connie, her husband, Ted, and their three sons were making a move from Atlanta to St. Augustine, Florida. Connie and her twelve-year-old son, John, were leading in a new Regency Oldsmobile sedan packed with boxes, and behind was Ted and her other boys in a large moving van.

Connie was sixteen miles south of Macon on I-75 "when suddenly she was confused about her location," the account stated. She was no longer on the interstate and found herself driving around a maze or roads with no buildings. Mother and son felt exhausted, but they continued driving until, suddenly, she and John were on their knees on an asphalt surface near aircraft hangers, "sobbing hysterically."

Looking up, there were several helicopters circling overhead, "with three round, softly grumbling space craft" also in the air. In front of them were several military men wearing fatigues and boots and a group of alien "Grays" who were simply "loitering." At that point, one of the soldiers warned her in a menacing voice, "If you ever…you will never see your family again." What she was being warned against revealing went unspecified.

Suddenly, Connie and John were back in their car, beings and craft gone. John fell deeply asleep, and Connie motored on, wandering around the maze of roads without seeing any structures. Eventually, she spotted a convenience store and stopped for directions to I-75. The clerk responded that she was on Robins Air Force Base and had to leave via the same gate she had entered. The clerk could not understand that Connie did not know how she had entered the base, but Connie got back into her car, eventually exited the base and found her way back to the interstate, about ten miles to the west.

At some point, Ted realized that Connie was no longer leading the pack. Thinking that she had fallen behind, he pulled over to wait for her and then

Alien abductee Connie Cannon believed that she was held at Robins Air Force Base by a team composed of aliens and humans. *Earline Miles.*

exited and started north on the interstate, closely inspecting the side of the southbound lane to see if Connie had pulled over for some reason. Finding nothing, he returned to the southbound lane and pulled over to wait. Unable to think of another course of action, he eventually continued to their new house in Florida. With great relief, he saw the Olds pull up three hours later.

Connie could not explain her disappearance, and the strangeness continued as she and Ted fell asleep on their screened porch. Both were disoriented for several days, as if suffering from PTSD. Connie felt that the idea of alien creatures and military men "was beyond my cognitive abilities" to process.

Later, John remembered being frightened and lost on the grid of streets, the convenience store and exiting the base. He had slept from that point to St. Augustine and lay down on the porch and slept through the night with his parents. He was disoriented for three days and slept a great deal.

The idea that aliens and American military personnel were cooperating in abducting humans and conducting experiments on them at an air force base is chilling. Unfortunately, following that experience, nocturnal "visitors" began to visit her home, not only for her but for John as well. "My son is an abductee," Connie believed.

Connie clearly remembered another abduction that occurred in the company of John. They found themselves within an enormous ship inside a vast, octagonal space with eighteen to twenty different sections. Many humans lay on gurneys, tables and stretchers, "some naked, others clothed," and there were a number of Grays. Connie and John were terrified by this sight and ran, vainly attempting to find an escape route from the ship. A Gray was in "leisurely" pursuit, as if not concerned with them getting away. As they fled, they learned via psychic communication that the aliens were intent on changing "their identities."

Connie and John came to a floor-to-ceiling control panel with a huge bank of computers and other equipment, "all with flashing lights in colors, and buttons and levers and switches." At this panel, she spotted a human acquaintance, Clark McClelland, a NASA engineer who had written a manuscript about his abductions and asked her to help with editing. The project was dropped, but they had exchanged e-mails and spoken on the phone. McClelland rotated on his seat, an ordinary rolling office chair, to look at them.

Oddly, he was not a victim; he wore a silver suit like those used by human astronauts and reassured them, "They can't hurt you as long as I am here." At that point, her memory ended, and she woke up the next morning. Nauseated and disoriented. Connie remembered nothing more but e-mailed McClelland to describe their experience. He freely described their shared moment. Connie demanded to know why she and John had been abducted and why McClelland was on the craft. She was particularly concerned about the "identity shift."

"Classified!" was his reply, and he was not "allowed" to say more. She was enraged: "Classified hell! My son and I were kidnapped and taken onto a damn spacecraft" and frightened nearly to death. Further, "you were at the controls." He did confirm the "identity shift."

During one abduction, a Gray placed an infant in her hands and told her that it was her child. Further, she had to hold, rock, talk to the baby, generally "nurture" it or the infant would die. She cried as she "held the ugly, deformed little thing." This alien hybrid was presented to her several years after her final child was delivered; her tubes had been tied to prevent further pregnancies.

Connie said that the child seemed to suffer from progeria, the rapidly aging disease that affects children, and resembled Gollum from *The Hobbit*: bald and short, with a big head. The infants she saw looked like "tiny, wrinkled up old folks" who cried soundlessly as tears rolled down their faces. She found

each experience "horrific," wondering if all the victims of progeria might have resulted from failed attempts at hybridization.

Each baby had a "noxious, inhuman odor," apparently from floating in containers "in yellow liquid tinged with green." After each session, she smelled the odor for days, despite her best efforts to cleanse it from her body.

One alien nursery she saw occupied the center of a large circular space with clear, stacked containers where she could see children of different ages, each floating in the curious fluid. When she held the children, they all seemed aware but made no sound, and their eyes were very sad. Each encounter left her "overwhelmed with sadness and depression."

While Connie's family lived in rural Georgia, Ted awakened her one night and announced, "Your friends are here!" When he had gone to a window to see why their five dogs had started barking, he saw three aliens, measuring from four to eight feet in height. The beings seemed to know they were being observed, looking up at the window before disappearing, which made the dogs immediately cease barking. Until that evening, Ted had not believed Connie's stories.

On another occasion in 2001, Connie found herself standing in a neighbor's yard in her nightgown. When a rumbling warned her that the aliens "were coming for me," she was terrified and attempted to hide. Suddenly, three round craft were seen above. As one descended toward her, she begged not to be taken but then found herself sitting on an ordinary desk chair, restrained by a metal strap across her stomach. She felt the ship move and spin before suddenly stopping, "quivering…like a leaf in the wind," and she felt ill. A Gray—described as sallow in color, with a thin, lipless mouth, a tiny nose and expansive black eyes—approached to within an inch of her face and ordered her, "in a metallic voice," to look down. As her fear turned to rage, part of the floor slid open. Through this section, a light beam from the craft illuminated the interior of a house, where she could see furniture and a family quietly sleeping. "What do you want me to see?" she demanded.

She woke up at home in bed, her right side numb and blood flowing from her right nostril. When she attempted to stand, the room spun. Fearing a stroke, she called for Ted, who rushed her to the hospital and carried her inside. A CAT scan showed no problems, and she quickly recovered. The scan did reveal a shadow on the right side of her nose in her sinus cavity. She was convinced it was an implant but told no one. Over her lifetime, Connie made a number of emergency room visits for bleeding that could never be explained.

Connie believed she had two implants, both visible on MRIs, as big as BBs. They have "tiny, cilia type protrusions" covering them. A radiologist reading a CAT scan described it as "anomalous," nothing to worry about. When doctors offered to remove them, Connie declined, terrified by the possible consequences.

All Connie remembered of one abduction was lying on a table surrounded by Grays. An alien sliced her scalp on her left side and implanted something behind her left ear. The incision was sealed by a "bright blue 'laser-like' healing instrument."

After midnight of September 6, 1993, John, then twenty-four, woke Connie and explained that he was bleeding in his throat. He had woken up in bed feeling ill and went downstairs to sleep on the living room floor. He watched TV until he fell deeply asleep again and woke up bleeding. Connie looked down his throat with a flashlight and found that he was bleeding heavily.

Connie took John to the hospital, where a doctor asked her to peer down John's throat, explaining what looked like a deep scalpel incision. Connie could not imagine how such an injury could have occurred. Sutures would have been difficult to apply, so the doctor gave John three applications of silver nitrate. Usually, only one application is necessary. When Connie checked John in the morning; she could find no evidence of the incision— his throat was perfectly healthy.

She thought that an alien intruder had come in the night and attempted to insert or remove an implant, and something went awry. After they returned home from the hospital, she believed that the aliens had returned to remove any evidence of the procedure.

Connie once attempted to remember more about her abductions with hypnosis but woke screaming. Apparently, an alien memory block was designed to deal with this type of interference.

The UFO/alien phenomenon can get even weirder. When Connie was seventeen, her forty-three-year-old father died of brain cancer. At the moment of death at Emory Hospital in Atlanta, he opened his eyes and said, "There's a big ship over there. I'm going to get on it." By that time, he should not have been able to see or speak due to brain damage. It was so unusual that the case was written up in medical journals. Connie believed that aliens are somehow involved in the afterlife.

In 1983, when Connie was forty-three, uterine cancer was discovered, requiring a radical hysterectomy. After that, the nature of her abductions changed. There were no more intimate probings, but aliens would get in

her face and create scenarios and then watch her reaction to each. Connie no longer has abductions but thinks she is still "tagged, tracked, and monitored."

Connie believes there are three types of aliens: the "ominous" ones who want to "annihilate" humans; the neutrals, who have their own agenda and don't care what happens to us; and the highly evolved aliens who seek to protect humanity.

Connie considers herself a "reasonable, rational, moderately intelligent" person, not given to hysterics. Her life was spent in nursing and work in medical research and teaching, and she derived great joy from life. She copes with the memory of her experiences by thinking of the best interactions with aliens. They can destroy her body but not her soul, she decided, saying, "I no longer fear them."

When interviewed by the MacGregors, Connie was in her seventies. She viewed alien intruders with justified paranoia but "accepted them as just part of my life."

ABDUCTION IN FORT OGLETHORPE?

On June 10, 2000, a young man in Fort Oglethorpe was home alone in a new residential neighborhood when he got bored and sat on his porch looking at the woods. There he saw "a series of white and red lights" that moved about a small area of dense woods three to four thousand yards distant. At first, he thought that someone was driving their vehicle through the forest, but he decided otherwise when the lights shifted to the "most beautiful pulsating color display" that he had ever seen. The object behind the lights rose to the tops of the trees and started slowly toward him.

The brave lad stood up and started toward the UFO, even waving his hands in the air to attract its attention. He had no fear and heard no sound as the craft neared. Closer, he saw it was egg-shaped, with three circular plates on the bottom. The craft "was a bright metallic color like a mirror surface or chromed titanium," he wrote to the Mutual UFO Network (MUFON) website. The lights were apparently part of the metal "and pulsed and vibrated every color imaginable like the brightest LED."

The young man then realized that the "egg" was surrounded by a "dark outer shell" that magnified the star field "to camouflage its true shape and size." Several small lights trailed the UFO, and "black sparks" shot around

it. When the craft moved, the stars in the camouflage seemed to move in a different direction.

The anonymous man was about to go inside to get his video camera when "my mind went blank." When he looked up again, the UFO "was much further away," and he was facing a different direction. He also felt "slightly confused." When his "mind snapped back," he raced inside, grabbed his camera and ran outside as the craft "moved in an arc straight up and accelerated very fast" without sound. Returning to the house, still confused from the experience, he realized that what he thought had been "a 10 minute experience had actually been more like 45 minutes."

Elements of this tale certainly indicate an abduction event. Also, afterward, the man became "obsessed with universal geometry and the occult," topics that previously had not interested him. In a recent X-ray of his head, apparently taken in late 2012, "a small object near my left ear… shows up brighter than the bones."

THE ALIEN DOCTOR IS "IN"

Seven years later, in mid-September 2008, a man was sleeping around 3:00 a.m. when he awakened, alert and with a need to urinate. As he returned to bed, he found the house "too still and quiet." He fell asleep immediately and vividly dreamed of being in a waiting room. A being woke him and inserted an illuminated probe that "could see through the skin, bones and muscle, and projected the image on like a hand-held machine."

The alien woke him and directed him to view the interior of his lungs on a screen. The smoker feared that his lungs would be filled with cancer, but the "doctor" spoke to him telepathically, saying that he would be fine if he would quit smoking. He found the "doctor" be to "very assuring." He woke at 6:00 a.m. and went about his business.

FLOYD COUNTY ABDUCTION

It was about 9:00 p.m. on April 22, 2006, when a young man was biking home on GA 100 after seeing a movie in Rome. He was walking the bike along the highway and turned his LED flashlight into the woods. The beam

illuminated three sets of eyes about seventy yards into the trees. Frightened by the sight, he jumped on his bike and rode quickly for home. Several minutes later, he looked into the forest again and saw the three sets of eyes still staring at him, unblinking, for at least ten minutes while he pedaled the bike at top speed. The creatures, moving "in a smooth sailing fashion," easily matched his speed through thick woods, even while he rode an estimated thirty-five to forty-five miles per hour down a hill. The aliens took advantage of a curve in the road to get ahead of the youth and cut him off. The lad next encountered his mother. It was 1:00 a.m., and she had taken her car to see why he was so late. The boy had lost four hours to an apparent abduction.

ALIEN NEEDED TENDER LOVING CARE

At 2:00 a.m. in the fall of 1992, a woman who lived in an isolated mobile home awoke to see an odd exterior light. She walked outside to find a mushroom-shaped craft hovering forty-five feet in the air, with a narrow column of white light extending from it to the ground. She felt compelled to approach the object but was telepathically told to "turn around." Obeying, she discovered an alien behind her, its large head shaped like a lightbulb and featuring large, black, round eyes. It was gray-skinned and four feet tall, with fingers topped by octopus-like suckers. It was lying on the ground, and she was told that it was ill and needed warmth.

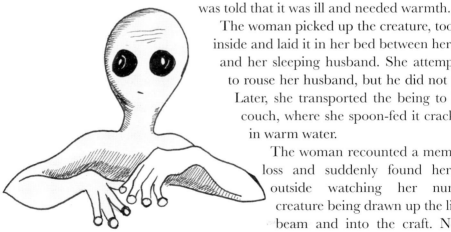

The woman picked up the creature, took it inside and laid it in her bed between herself and her sleeping husband. She attempted to rouse her husband, but he did not stir. Later, she transported the being to her couch, where she spoon-fed it crackers in warm water.

The woman recounted a memory loss and suddenly found herself outside watching her nursed creature being drawn up the light beam and into the craft. Next, she realized that there were five additional aliens staring at her and standing in a line as straight

"It was gray-skinned, four feet tall, with fingers topped by octopus-like suckers." *Illustration by Sarah Haynes.*

as a military formation. The creatures then turned as one and individually rode the light shaft into the UFO. As the craft streaked off, it made a thunderous sound.

VARIOUS ABDUCTIONS

At an undisclosed location in Georgia at 12:45 a.m. on April 28, 2001, a fishing party was returning home when the men stopped on the side of the road, where they noticed an "odd-looking shape" hovering above the tree line. Everyone left the vehicle to observe the UFO and lost track of time. The craft they watched was eighty feet in diameter, with a row of illuminated windows and a raised area on the center top showing the outline of a hatch, pierced for a window. Through it they saw a being moving about the interior, although no features were discerned. Abruptly, the men got back into their car one hour and forty-five minutes later, somewhat curious about the missing time. They discussed telling authorities of the incident but recalled how an earlier witness to a UFO sighting had been ridiculed; they elected to remain silent.

On New Year's Eve 1999, a mother and son saw alien beings in their bedrooms. Three days later, a sixteen-year-old daughter awoke at 4:15 a.m. to find a similar creature holding one of her legs. The creature seemed surprised at her consciousness. The teenager suddenly had a mental image of a spacecraft in her backyard crewed by five aliens.

Late one night in the summer of 1993, an Albany woman was quietly reading while her children slept. She reported that an odd feeling enveloped her home, and she was discomforted by giggling that originated from her daughter's bedroom. Investigating, she saw a small, childlike being sitting on the girl's bed. This entity resembled a small girl with short, tousled hair. As the mother entered the room, the creature disappeared with a sudden burst of laughter.

At 9:00 p.m. in 1962, a man living in an Atlanta boardinghouse was picked up by a waitress who worked nearby. He would normally have taken her to his room but found himself and the girl in the woods, where they heard noises, the crunching and crackling of small saplings and undergrowth. He remembered telling his date, "We need to get out of here," followed by "a complete blank." He wrote to the National UFO Reporting Center (NUFORC), "It was as if time stopped still." He did not recall leaving the

woods and never saw the woman again. He began remembering some of the incident thirty-five years later and wished that he could recall additional details of the experience.

INCIDENTAL ALIENS

Not all alien experiences include abductions. Some entities go about their nefarious activities without abducting and probing.

Hog Hunters Encounter Aliens

At 2:30 a.m. on the morning of August 5, 2006, three hunters were running their dogs after wild hogs near Bonaire in Houston County when they spotted a light shining on a hill in the forest. The men decided to investigate the mystery, and sixty yards into the forest they "heard a loud whooshing sound" that caused their dogs to tuck tails and whine. As the hunters edged forward, the lights dimmed and "another swooshing sound" was heard. This was followed by the sight "of two small green 'midgets'" that raced from behind a tree on the hill to a craft described as a large "concrete mixer" festooned with lights.

The hunters withdrew, downed a can of courage each and followed their dogs up the hill to find the UFO and its occupants departed. The woods had fallen silent, lacking even insect sounds. The men returned the following day and found no trace of the craft or beings. That night, one of the men found his favorite hunting dog, named Judo, sick and unwilling to eat. The dog soon died, suggesting that it was somehow affected by the UFO.

Another dog precipitated the next account, on the evening of December 28, 2004, in Woodstock. A girl named Katie had ventured outside to look for a cousin's dog when she encountered a completely black, seven-foot-tall figure, rapidly approaching from the woods behind her house. The dog, which had returned, appeared hypnotized by the apparition, which remained silent as it moved through dry leaves without making a sound. The terrified girl and aroused dog raced indoors and saw nothing more.

In Macon at 2:30 one morning, three men sharing a house were alarmed by loud banging noises and bellowing sounds from outside. One man ran to a window in the bathroom as a hairy, three-foot-tall being with horns on its

head and hands ran past and squatted in the bushes. Its face was not seen. Other residents also heard the banging.

Strange events were afoot in rural Grady County in mid-September 1994. In an isolated area, residents had observed a large orange sphere floating three feet off the ground. At 9:30 p.m. on September 12, a woman on a dirt road surrounded by forest rounded a curve to confront four humanoids, each four feet high with large heads. The aliens ran quickly into the woods and vanished.

Sometime in 2001, a Dahlonega man spotted a UFO floating above the forest near his home. Suddenly, it shot a low-intensity beam that "illuminated the forest," repeated another fourteen to fifteen times. Then it emitted a laser beam that hit a large tree in the woods, which "burst into flames."

Alien Aeronaut?

On March 4, 2007, at 2:00 a.m., three people were occupying a room on the seventeenth floor of the Marriott Marquis Hotel in Atlanta when two looked out the window and saw "a cloaked person soaring off the top of a building below them." A third witness also looked out the window and said that the being "was moving like an acrobat in midair." It had arms and legs and appeared to be holding "a jetpack," but without sounds or flames. It disappeared from view.

Did He Dream of a Genie?

It was night in January 2006, and the security guard at a granite quarry outside Atlanta sat in a dark guard shack tuning his guitar when he saw "dark smoke come out from behind the heater. It didn't smell or look like smoke, but stayed together and slowly moved in one direction." While he watched, fascinated but unafraid, "it began to take the form of a large cloud." He watched as "the cloud turned into a great robed man." The guard jumped against the wall, but the enormous figure looked into his eyes "and a great comfort" enveloped him.

The ten-foot-tall being sat on a crate only inches from the guard. The figure had a long, brown beard "and large, comforting eyes, and giant almost perfectly woven locks from his beard." It then communicated with

the man using only its hands and eyes to gesture, but its meaning was "completely clear."

Suddenly, the guard noticed that another figure, looking like an ordinary person, had appeared "out of nowhere," with "jet-black hair slicked back and shiny" and blackish, smoke-colored eyes. It never spoke—just gazed outside the windows "as if waiting for something." The two beings were clearly related.

The excited man started babbling to his strange visitors, "Who are you? Where are you from? Please visit me any time." After twenty to twenty-five minutes, the giant returned to its smoke form with a concerned look and pointed at a wall, where there was a can of gasoline and a fire extinguisher. The guard walked to the door to see if any drivers were around for witnesses, but as he turned back, the cloud reentered the wall at the heater. The beings never returned, and their mission was never clear.

PEACH STATE UFOS

THE CLAXTON BOOMERANGS

On March 29, 1984, Mitchell E. Peace, editor and publisher of the *Claxton Enterprise*, wrote that over the years the newspaper had received UFO reports but decided not to publish them. However, when he received an account from a witness described as having "an executive position with a prominent Claxton business firm," he made an exception to this policy.

For the story, the witness was named Mrs. Betty West, and her teenage daughter, also involved in the encounter, was dubbed Cynthia. Between 8:00 p.m. and 8:30 p.m. on March 21, the two decided to take a drive in the country while Mr. West attended a meeting. They were motoring south on Perry Road in southeastern Evans County, near an area called the Level, when Mrs. West saw a strange light shining through trees on her left. "As we topped the hill, I slowed to a near stop," Mrs. West said, "and out hovering above the field were three unidentified flying objects. There was one large one and two smaller ones."

Each UFO was shaped like a boomerang, with two large white lights in the center, and on their flat noses was a row of smaller, multicolored lights blinking in rapid sequence. Each wing sported two red lights, and the tip of each wing had a large red light. "We could see the form of the object," she continued, because of the lights from Claxton. She "had never seen anything like it in my life" and directed her daughter's

Boomerang-shaped UFOs floated over a road in Claxton in 1984. *Illustration by Sarah Haynes.*

attention to the airships. At that moment, the large one started to move in their direction.

"After I saw them moving I became terrified, I pushed the gas down and was trying to look and steer at the same time. My daughter was watching. She said 'Mama, slow down, you're going to wreck us,' because I was swerving. I did slow down, but I kept going, and 'it' kept coming. The first one—the large one—went over the car. There were some pine trees just on the other side of the road and it just cleared the tops of the pines."

The UFO passed directly over the car, and the daughter, looking up through the open T-top of the car, had a perfect view. The bottom of the object appeared to be dark metal, and the wingspan was forty feet. "It just floated over the car," Mrs. West continued. "There was no sound at all. I didn't notice any heat. I didn't notice anything other than it just quietly floated over the car."

She considered stopping and running into a house for shelter but continued driving. "When I looked back over my shoulder the last thing I saw was the 'wing' passing over the car. I don't know where they came from but I know they could defy gravity. And they didn't make a sound. Something that big, moving that slow, that close to the ground, and it didn't make a sound."

After reflecting on the experience, she decided that "I have seen something from another world. It's the kind of thing you don't get out and advertise. It's a personal thing. When you see it happen, you know what you've seen, but you can't make the whole world believe what you've seen. You just have to accept it for what it is."

According to the paper, both mother and daughter believed that "they had a close encounter with an unidentified flying object (UFO)." The Claxton Boomerangs haven't been seen since.

UFOs Terrorize Teens at Boggy Bay

At 7:00 p.m. on January 22, 1984, a teenage couple, Danny Thrift and Janet Curry, were driving on Swamp Road in the Boggy Bay area of Ware County when they saw an aircraft at treetop level perpendicular to the road. Fearing that it was an airplane in trouble, Thrift stopped his car on the road, but at that point the UFO "started moving fast" and turned toward them.

Thrift said the object had three L-shaped lights, two red and one green. They blinked on and off several times but were primarily constant. Thoroughly frightened, Thrift accelerated. "I was trying to speed away and it kept up with me," he told Jack Williams III of the *Waycross Journal-Herald*. "It got right over the car and glided over us. It lit up the whole inside of the car. I felt I was in danger. I felt like it was after me."

The craft followed the vehicle for one hundred yards, hovered above it and shined an intense light down. "It was like something turning red hot," he said. At that point, it flew away.

Thrift unashamedly reported that both he and Curry were so frightened they cried. "I've lived out here all my life, and I've never been so scared in all my life," he said. Thrift returned home and reported the unsettling encounter to the Ware County Sheriff's Department, which dispatched Deputy Carl James to investigate. Thrift told the officer that the aerial object tried to land on Swamp Road and nearly struck his car. Thrift believed the craft was a secret military project: "That's what it's got to be. It didn't make any sound."

The first report of a low-flying aircraft along Swamp Road was made by an off-duty deputy, Randy Moore, who said it was a low-flying airplane with its landing lights illuminated. A total of six people saw the mystery craft. "We do get frequent reports of low-flying aircraft in that area," said Chief Deputy Harold Guinn, as student pilots practice in the thinly populated locale. However, the airplane theory does not account for the UFO's extremely low level, the way it lit up the car and the total lack of sound.

Physical Effects from a Radioactive UFO

According to UFO Evidence, at about 8:00 p.m. on October 18, 2010, Joshua, with his fiancée, Laura and their friend Abbie, drove through Collins, near Reidsville, and started to explore dirt roads, roaming through woods and pastures to pass the time.

At about 8:40 p.m., they sighted what appeared to be "military aircraft… pursuing a very vague object." The UFO, appearing "seamless against the sky," at first resembled a dull but moving star. As the UFO was about to pass overhead in bright moonlight, the witnesses stopped and exited their car. When the object was above them, they saw that it was shaped like "a soft featured arrowhead" with "three obvious lights, one at each point, and a design in the middle." The design, also shaped like an arrowhead, was lighter than the UFO, which was black. The object was estimated to be enormous, three to four thousand feet long; the pursuing aircraft were far smaller.

When the UFO vanished inside a cloud, the aircraft began circling the area. A "bright orange tinted light suddenly" penetrated the cloud, and the UFO emerged to "speed past the aircraft." The UFO began a turn, which revealed it to be a three-dimensional craft. It then "began a slow diagonal ascension" and disappeared as "the aircraft began swarming the area where it vanished." The aerial show had lasted an hour and a half.

In a field, the trio found a bull and horses "huddled together like a group of frightened children," said Laura. After the three had left their vehicle, Joshua "suddenly felt rather ill. Extremely fatigued." His face "felt like it had been doused with boiling water," and the women reported the same symptoms. In the morning, Joshua was "extremely tired and beat," he wrote. "I felt as if I'd been beaten with a bat." It was difficult to rouse Joshua and Abbie out of bed, and she missed a morning class "because she couldn't really move."

None of the witnesses could eat for twenty-four hours, and their "skin felt burned like radiation poisoning," the woman said. The new 2010 Hyundai they had been driving also developed problems.

UFO Crash in Georgia?

An alleged crash of a UFO occurred on the afternoon of November 28, 2006, according to a source we shall call Adam, who posted his account on the website UFO Experiences. That day, several credible witnesses observed "a bright object crash into the trees" behind the giant Pratt & Whitney complex on U.S. 80/Macon Road in eastern Columbus, as reported by WTVM Channel 9 TV. The incident was labeled "a possible plane crash."

Assuming that it was a downed aircraft, firefighters, police officers and one FAA official, later reinforced by Georgia state troopers and several

unidentified personnel, with the assistance of helicopters, vigorously searched the area for five hours, but "nothing was found," the fire and police chiefs announced. The head firemen declared that "sometimes people see what they think is something and it really is nothing."

Despite the fact that nothing was found, the area was cordoned off, and several large tractor trailer trucks were admitted. Presumably, they later exited with cargos of "nothing."

The police, fire and FAA announced that "neither the local Columbus Metropolitan Airport or Fort Benning Lawson Army Airfield had shown signs of any craft or object on radar" at the time of the incident. However, Adam, the author of the report, spoke to the lead meteorologist at a Columbus TV station, who stated that "something" had registered on their radar at that time.

At 1:00 p.m. on November 29, Adam, who is a professor with a PhD, and an associate, also a PhD, were driving along the perimeter of the Columbus Metro Airport "when we both saw a completely unmarked, white 727 aircraft." As the plane taxied past, "my companion's vehicle lost all power, all gauges went dead, power steering, engine, everything and we glided to a stop," Adam wrote.

Fearing a serious mechanical malfunction, the friend took out his cellphone to call for assistance, but it was inoperative. Adam checked his own device, which was also dead. As they sat, they realized that the 727 "had no tail markings of any kind, no tail number, nothing." The plane also had "a strange finish," which looked "whitewashed."

When the plane was one hundred feet away, the car engine restarted, and their cellphones revived. Adam immediately called the airport and was referred to the "police/fire station." A man curtly told Adam "that was a private plane, thank you." Half an hour later, he phoned CSG Aviation and learned from a woman that it "was a government plane." Adam asked how she knew, and the reply was, "It had picked up something which it loaded into its rear section and it also refueled. A man in a coat and tie came from the plane and paid for the fuel with a credit card which had 'U.S. Treasury' on it."

A third call to the airport administration office drew this response: "I was mistaken, that no plane, much less a 727, had landed or taken off during the time period I gave." Adam concluded, "I FIRMLY believe that SOMETHING WAS FOUND AND RECOVERED, and that it was taken from Columbus the next day in the strange and unexplained 'ghost plane' my friend and I saw."

NUFORC spoke to Adam and reported that "he impressed us with his sincerity." Unfortunately, there is absolutely no physical evidence of the UFO that some believe crashed in Georgia.

ADDITIONAL 1973 UFOS

Close Encounter at Rutledge

In the fall of 1973, unprecedented numbers of UFO sightings erupted in Georgia and spread throughout the United States.

Morgan County's impressive UFO encounters began on the night of October 20, 1973. Just before 8:00 p.m., Elaine Tannerhill picked up her two-year-old son, Michael, and started for their home in Rutledge. They soon saw in the sky an object that Elaine described as "two long, blue, shinning clouds blinking at one another." The lights were slim and looked like fluorescent bulbs. "The lights were going on and off," she stated, "and formed into a larger mass that looked sort of like the moon. The lights became blue-green at the top level and, the nearer I got, took on more of a formation. The object had an oval shape, and as it came toward the truck, it seemed turquoise in color."

Michael called it an airplane, but Elaine was certain it wasn't, as the UFO approached and then followed the truck so closely that she thought it had attached itself to the back of the pickup. She stomped the accelerator. "I must have been going over a hundred miles an hour," she said. "I was hoping a patrolman would come along and follow me too."

Mrs. Tannerhill turned into a driveway, and the UFO followed, hovering fifty feet above a house while Elaine discovered that no one was home. She hurriedly continued her journey, turning down a long drive to the house of Billy Hawks. It followed her and again hovered above the house as she entered.

Several minutes passed before the panicked Elaine could explain what had happened. She and the Hawkses stepped outside to find the UFO keeping station above the residence. Five minutes later, the object climbed, blinked several times and faded away.

This case also provided a rare physical trace element. As Elaine ran to the Hawks home, "the thing scorched my face," she claimed. The Hawkses noticed that one side of her face was burned, as did a reporter four days

later. "Some people think maybe what I saw and what attached itself to my truck was a cloud of gas," but she rejected that ridiculous notion, inspired by atmosphere releases of gases meant to study weather patterns.

When Elaine told her boss, Mrs. Carter Campbell, about the incident, she admitted to having seen the lights earlier as she drove to Rutledge. "They frightened me too," she said. At the home of Herbert Autry, binoculars and a telescopic sight were trained on the UFO, and a number of people watched it hover. Three other people in Morgan and Greene Counties witnessed the same thing.

A Rural UFO Convention

For weeks in a six- to eight-square-mile area of Upson and Crawford Counties, a number of UFOs regularly entertained the locals along U.S. 80. At length, *Thomaston Times* reporter Leon Smith decided to investigate. At dusk on October 25, 1973, he traveled to Blalock's Grocery Store on the county line. Mr. and Mrs. Howard Blalock and their neighbors had observed objects for two weeks. Howard, son Brad and neighbor Chip Gaultney took Smith to a quiet, isolated hilltop six miles off the highway with no trees to obscure their sight.

The first UFO appeared at 9:00 p.m., reddish-orange lights to the north:

> [They] *started an erratic run southward, sometimes fast, sometimes slow and often in a movement like a child hop-scotching. It moved across the sky, dropped behind the tree-line and in a few minutes popped up again and floated back to the north before suddenly disappearing. Five more UFOs appeared in the next thirty minutes, two simultaneously in the sky; first they were not there and then they were. These also moved in irregular fashion, up and down a little, north and south and one to the northwest.*

Airplanes overflew the area during the sighting, easily demonstrating that the UFOs were not normal aircraft. They were silent; the planes could be heard. Airplane lights blinked; UFO lights generally remained steady. The UFOs rose and fell in the sky, while the planes were steady in altitude.

Blalock was a little disappointed with this show. "They're smaller tonight," he said. Some appeared to be close and thirty-six inches in diameter. Sometimes they were as fast as the tracer bullets that Blalock fired during World War II.

Smith interviewed other families in the area. They reported watching the objects from their porches and while fishing in the Flint River. All agreed that the unidentified lights seemed under intelligent control. They "make sharp turns, run at varied speeds, stop and start up again, fly in formation at times and run in opposing directions simultaneously," Smith wrote. "We just don't know what they are," Blalock said. Back at the store, groups of people were watching for UFOs, and in the morning, children climbing aboard Blalock's school bus chattered about the previous night's UFOs.

NINETEENTH-CENTURY UFOS

Unidentified Flying Objects have been with us under many guises for hundreds of years. In the nineteenth century, they were called ghost lights, death lights and will-o'-the-wisp. Today, we might attribute such occurrences to ball lightning, swamp gas or something wholly otherworldly. Regardless of the labels, they remain unidentified. Of the following four accounts of nineteenth-century UFOs and one from the early twentieth century, four occurred in the southeastern corner of Georgia.

This interesting report was initially posted in the *Macon Telegraph* and reprinted in the *Savannah Morning News* on July 16, 1885. A few days earlier, a frantic servant working for a family on Walnut Street in Macon ran to the woman of the family, saying that a ball of fire had approached close enough to burn her. Immediately following this announcement, "the alarm of fire was given," the article stated, as three separate witnesses observed a "ball of fire" fall on Stewart's Stable. Soon afterward, the stable burst into flame.

According to the *Savannah Morning News* of December 20, 1893, a Ware County resident related a strange tale that had happened to him one dark night five years earlier in December 1888. The man, a farmer, was returning home from church when he approached a creek crossing near the Appling County line. At the creek, his mount, described as "a fine saddle horse," stopped to drink.

Abruptly, "there appeared the most brilliant light I have ever seen," the man stated. The area for "many yards was illuminated by the strange brightness. The water looked like a stream of silver and the earth and trees were also like silver. The light was the same everywhere, and no cause was seen for its sudden appearance."

The horse, which also saw the bizarre phenomenon, "was terribly frightened and became weak in the legs. He sprang almost from under me and ran up the hill. I held on the best I could," The man admitted that he "was no less frightened than was the horse," and "cold chills ran down my neck." He feared "being snatched up into judgment, as I believed that the world was on fire and that the end had come." He attempted to pray, but the terror of the light and his precarious position in the saddle prevented that.

At the crest of the next hill, the man saw that the light still shined behind him, but forward, toward home, there "was intense darkness." The terrified horse continued its run, stopping only when it reached home. The witness "fell on the ground from sheer exhaustion." Subsequently, he admitted, "I have never returned to that creek at night."

Another witness, named Graham Stubbs, who was traveling behind the first man, "saw the light and was badly frightened," the account ended.

"A Ride Among Ghosts" declared a headline in the *Savannah Morning News* of January 5, 1893, of an incident that had occurred just a few nights earlier. A gentleman of good character was driving his horse and buggy on a road that crossed the Satilla River. He had just approached the covered portion of the bridge when "a bright light filled the space," the press account stated. The cold, dark, rainy night was illuminated to such intensity that his horse shied and refused to continue. The rider dismounted and led his reluctant animal across the bridge. The light remained at the bridge until the man entered a swamp and his view of the remarkable sight was blocked. Unfortunately, this is when the terrifying part of his strange trip started.

At the center of the swamp, where the darkness was nearly total, invisible hands began to touch his back and shoulders. He looked all around for his tormentor, but no one was present. The phantom hands continued to explore different parts of his anatomy. When the entity laid a hand on some part of his body, the man would shift one of his hands to that location, "but immediately the ghostly hand would rest on another part of his body." The phenomenon ceased as he emerged from the swamp. At home, he barely had energy enough to put the horse and buggy away and enter his dwelling. He thought that another half mile of swamp would have rendered him unconscious.

Those who heard his story suggested that the light was the result of swamp gas and the hands the result of his isolation in dark swampland. The witness swore to his experiences "and did not care to discuss the subject any further," the report concluded. Perhaps this was an early alien abduction?

On December 12, 1897, the *Savannah Morning News* reported a railroad mystery light sighted by engineer Alvin Johnson as his locomotive approached the Kettle Creek trestle, located three miles from Waycross on the Waycross Air Line. The light, described as being the size of a standard light mounted on a locomotive, was "swinging across the track at the center of the trestle… Johnson and his fireman, fearing it was a sign warning of danger at the creek crossing, immediately reversed the engine, and as soon as the train shuttered to a halt, the light disappeared." In the past, the ghost light had been seen at the same location by locals, but no one could venture a reason for its appearances.

For whatever reason, paranormal phenomena often occur in the presence of bodies of water, and bridges and swamps also host strange occurrences.

The final account occurred in the early twentieth century. When the midnight train from Jacksonville, Florida, arrived in Baxley, the engineer and conductor declared that a mystery "airship" had trailed them since they crossed the Florida line. The few locals awake at that time also observed the unusual craft and found menace in its presence. "The night crew at the electric light plant turned off the current and camouflaged the town for some minutes to throw the aeronaut off his course," the account stated.

Theories, reprinted in the *Savannah Morning News* on April 5, 1918, were a military airplane, German spies (this occurred during World War I) and bootleggers running illegal liquor through the skies.

Coastal Georgia's UFOs: Brunswick, St. Simons Island and Jekyll Island

UFOs appeared over Brunswick at 11:15 a.m. on March 26, 1950, according to the *Brunswick News*. The five craft, in two flights of three and two, were described as round plate shapes with flat bottoms. Frank Preston had a clear view from the ground with binoculars. From the air, in two separate planes, were pilots Clarence Dubs and J.M. Rozier, both members of the airport commission, flying from Brunswick to St. Simons Island. On the ground at St. Simons, they found two other men observing the craft, one of them also a pilot. They agreed that the silver objects flew at about two thousand miles per hour at an altitude of thirty to forty thousand feet and left vapor trails. They were sighted twice, once flying south toward Jacksonville and then again returning north toward Savannah. Dubs

thought they were experimental aircraft being secretly developed by the U.S. government.

The following report was submitted to the National Investigations Committee on Aerial Phenomena (NICAP). At 8:45 p.m. on February 18, 1973, a UFO described as a bright light illuminated from within was viewed above Brunswick by four witnesses. "The object passed over a house," one witness said, "and looked as if it was going to land in the street, but kept going." It flew over another residence and passed from view. The light, twenty-five feet in diameter, had "no wings or tail…It was disc shaped with protruding ends" and left no exhaust. It flew about ten miles per hour from the northeast to the south and then turned west. The remainder of these sightings were posted on the NUFORC website.

At 10:00 p.m. on June 15, 1996, a married couple were visiting old friends on Jekyll Island. After dinner, the four took a walk along the beach. When they passed an older couple, they saw the man pointing into the sky and saying to his wife, "There! Did you see it that time?" The four glanced into the sky but saw nothing and continued on their way.

As the two couples returned twenty minutes later, they found the older couple still peering into the sky. This piqued the curiosity of the man who posted the report, and he asked what they were looking at. The older man pointed out "a particular grouping of stars." Three of the four were able to see what was happening.

"About every 5–10 minutes, way up in the sky, it appeared as though one of the stars would shoot across to another star and stop. After another couple of minutes, it would shoot to another star and stop. It kept doing this in the same triangular pattern between the same 3 stars."

A couple were leaving a Brunswick grocery store on November 5, 2005, at 5:25 p.m. when they spotted "a brown cylinder shaped craft." It was five hundred feet in the sky and "seemed to be composed of hundreds of brown balls on all sides." The object "was changing shape" as it flew from east to west.

Around 8:00 p.m. on January 16, 2009, a man was driving north on I-95 near Brunswick when he saw a massive triangular UFO three hundred yards to a side at an altitude of fifty feet. He drove directly under it and provided a detailed description. It "was straight and flat," without any curves, and appeared to be metallic. There were four lights on each side and three in the back, all regularly shaped, rectangular and colored red. Lights on the edges "wrapped around both sides." Lights on top turned on and off, while the bottom lights pulsed dim to bright.

COLUMBUS UFOs

Columbus's first UFO sighting was made in early April 1950 by Mrs. Joseph E. Patterson, who spotted a white disc flying over East Highland "faster than any plane." Soon afterward, pilot Charles Kolhase, flying toward the city at 4,000 feet, observed a UFO 6,000 feet above him. "It left a faint vapor trail and seemed to be going about 600 miles per hour." He watched it for half a minute, and it "didn't have projecting wings like the usual planes, and I judged it to be about 110 feet across." He described it as "some adaptation of a jet-propelled flying wing."

A Columbus couple, returning home at 11:00 p.m. on August 7, 1952, were near Woodland when they saw two large, bright saucer shapes zip past the front of their car before suddenly shooting up into the sky. "They were large, well-lighted things," the husband said, and flying side by side. Lights encircled the rim of the objects.

Three days later, another Columbus couple sighted a pair of flying saucers near Midland at 10:00 p.m. These, resembling "a man's top hat, glowing brightly," appeared from nowhere and were in sight for two minutes. The UFOs floated at treetop level, "like they were following the road to Atlanta," the wife stated.

At 1:00 a.m. on June 22, 1962, Lee Henkel Jr. and Harold Hughes spotted three UFOs over Hilton Heights. Two, bright red, flew directly overhead to the north at an altitude of eight thousand feet. A third, similar object plunged rapidly toward the ground a mile to the south. The UFOs, described as larger than stars, gave off an orange glow that occasionally shifted to green.

Receiving these reports at the Muscogee County Airport, a Federal Aviation Administration employee in the tower watched brightly lit orange UFOs flying north. However, radar did not register the phenomenon.

Early on the morning of November 26, 1968, Columbus policeman Harold W. Shepherd sighted a UFO high in the sky that seemed to consist of two objects joined together. It shifted colors from bright green to light orange but always displayed a silver glow. Shepherd alerted another officer, Leonard Hurley, and they described the object over the radio as they watched it for half an hour.

WHEN A UFO IS AN IFO

There are skeptics who accuse UFO researchers of being undiscriminating. Critics claim that the UFO community too readily accepts all reported sightings, regardless of the reputation of the witnesses, the strangeness of the scenario and easily explained natural phenomenon or manmade objects.

Not true. Okay, not *always* true. Most UFO sightings are easily explained, but those are rarely reported by UFO researchers, who concentrate on the unexplained cases. The reputation and character of witnesses are a serious consideration and have much influence on investigators. All witnesses are not created equal—some are simply more believable than others. Researchers are usually serious, educated individuals who confer regularly with law enforcement agencies, the National Weather Service and physical and psychological scientists in their investigations.

The following is a good case study of a spectacular mysterious object in the night sky that was explained to the satisfaction of most in the UFO community (let's admit it, there is a fringe element that accepts all reports of strange phenomena without reservation).

Between 10:20 p.m. and 10:30 p.m. on December 10, 1998, a dozen people in west-central Georgia reported an enormous UFO that thundered overhead below the speed of sound. UFO investigator John Thompson and his wife happened to be among the witnesses, seeing the object and hearing it for three minutes.

A former Air Wing marine (First Marine Aircraft Wing, III Marine Expeditionary Force) who found himself directly under its path gave the best description. According to Thompson, he said the craft was "flying under 1,000 feet and when directly overhead was seen only as a fireball of orange-yellow color making a huge roaring noise…he said it appeared to have a dark grey bottom that was slightly illuminated." From the rear, "it appeared to be of a long delta shaped craft with a rectangular shaped boxed-off end, with four fires coming out of the 'box.'"

The marine saw no wings or ordinary airplane lights and thought it resembled the infamous "Aurora" space-plane often reported in the American West to the accompaniment of tremendous noise. It might have been a cruise missile except for its size, "considerably bigger than an F-16."

This UFO was faster than a prop plane and slower than most jets, but the noise "in both intensity and duration" was unparalleled. The craft rattled windows fifteen miles away. The marine and others thought this might have been a jet plane with severe engine problems and about to crash. But it didn't.

Sightings of a large UFO in Central Georgia in 1998 was identified as a B-1B bomber on a training mission. *Earline Miles.*

The marine's report was the most detailed sighting of many that were received in Troup, Heard and Meriwether Counties, where a sheriff's department dispatcher saw it. "A meteorite, cruise missile, black budget craft (Aurora), disabled military aircraft, UFO imitator, or even true UFO are options" were given as explanations, Thompson wrote. Thompson plotted the object's path and speculated that it might have been making for Hunter Air Field near Savannah, which has a long runway and is located near the Atlantic Ocean.

Soon after this sighting was published on the web, Bill Rose, a British aviation expert, responded with his solution: "a B-1B 'Lancer' which is a large supersonic bomber with a long delta winged shape (with its wings folded). The aircraft is powered by four turbofan engines and optimized for low level flight….I can promise you they are very noisy beasts." Their color scheme also matched the reports from Georgia. Rose consulted a map and concluded that the aircraft was making for Robins Air Force Base in Warner Robins, home of the 116th Bomb Wing, which flew B-1Bs. He hypothesized that one was "on a secret training mission" for operations in some troubled area of the world.

"I'm inclined to agree," Thompson responded, and most residents of Central Georgia concurred.

My family lives near Robins Air Force Base, which was once a SAC base that hosted enormous B-52s and other aircraft. My wife and I taught in the area, and our home and schools were once regularly rocked by sonic booms (despite restrictions, which some pilots occasionally ignored). You have not lived until you have experienced giant bombers taking off one after another from a major air force base.

ARCHAEOLOGICAL MYSTERIES

THE MUD VOLCANO AND TEMPLE AT NODOROC

Barrow County once had a bizarre natural feature that attracted the attention of ancient Georgians. Within a valley surrounded by gently sloping hills, there was a boiling spring noted for bubbling mud that occasionally acted like a miniature volcano, belching smoke and flames from methane explosions.

"Not a sprig of vegetation of any kind grew near it and the timber growing in the vicinity was badly dwarfed," recorded Jackson County's first historian, G.J.N. Wilson, in *The Early History of Jackson County, Georgia*. He continued:

> *A closer inspection revealed the astonishing fact that the lake was not water, but a body of from three to five acres of smoking, bubbling, bluish mud of about the consistency of molasses, whose surface ranged from two to three feet below the surrounding solid land. The mud near the banks was slightly in motion, but its action gradually increased toward the center until one-half acre had the appearance of moderately boiling water. The movement of the smoke which rose from the bubbles was sluggish and it united in a funnel a few feet above the surface.*

One geologist compared it to mud volcanoes found in Burma.

To guard against the demons they believed lived in the cauldron, Native Americans constructed a unique structure, a stone temple called Nodoroc,

described as elaborate and artistic. The temple, which had the form of an equilateral triangle, was eight feet high and each side was twelve feet long. The only entrance, large enough for a man to enter without stooping, opened on the side facing the pit. An altar inside the temple (perhaps used for sacrifices) and the walls were black from centuries of ceremonial fires.

The stones used in the temple were black granite slabs that had been quarried and crudely dressed. The dimensions of the stones varied but were skillfully fitted together. Each stone was roughly one to two feet wide, one to three feet long and six to eight inches thick. Georgia governor George R. Gilmer recovered the stones and reconstructed the temple at his home in Lexington 180 years ago. Only a few stones remain from the temple today, and they have indecipherable hieroglyphics engraved on them. One was donated to the Barrow County Museum in Winder.

Nodoroc is thought to have been a place of torment and even "the gateway to hell." It is popularly believed that criminals and prisoners of war were periodically thrown into the lake as live sacrifices to the gods. If the volcano erupted unexpectedly, then an innocent person was quickly dispatched to calm the angry deities. Although local lore has the temple five to seven thousand years old, a better estimate is two thousand years or less.

In the museum at the Etowah Indian Mounds was a shell gorget bearing a Numidian script from ancient North Africa. *Jim Miles.*

Nodoroc's Native American owner, Umausauga, called it "the horrid boiling smoking place. It burns! It burns!" He was reportedly anxious to sell it to white settlers because "white man afraid of it not. Indian is afraid to go....Great Spirit is not there."

The fiery volcano that once bubbled mud and ejected nauseating gases and columns of black smoke visible for miles is now a five-acre depression composed of blue-black ooze that supports scrub pine trees. Geologists have determined that the mud bog has been active in two different eras, once in the distant past before humans arrived and the historic period starting two to three thousand years ago. In 1800, the land was owned by John Gosset and his family. Gusset was plowing one day when his wife frantically called him home. There was intense activity in the mud bog, and then an explosion threw mud for a considerable distance. Subsequently, the bog sank several feet below the surrounding countryside and cooled. It was the final eruption of the now dormant "mud volcano."

Around 1900, John Harris purchased the land and drained part of the swamp to grow corn. He was forced to fence the area because his cattle kept getting stuck in the deep mud. "It's real dangerous," said a member of the Barrow County Historical Society. "If you step off in some of that soupy mess, you're gone."

The site is near the head of Barber's Creek, three miles east of Winder and not far from Fort Yargo State Park.

THE CEREMONIAL COMPLEX AT YAMACUTAH

In Jackson County on the North Oconee River, there was a "Holy Ground" named Yamacutah that consisted of an earthen circle 450 feet in diameter. Situated in the precise center was an earthen mound 6 feet high and 17 feet in diameter. In the center of the mound was a statue carved into the image of a human. Crafted from soft rock, the four-foot-high idol had a crude shoulder but a perfect head and facial details, with a long, slender neck, receding chin and forehead and realistic eyes, which watched the east, presumably for the rising sun.

Four 150-foot-long paths radiated from the mound, marking exactly the directions north, south, east and west, each terminating at stone altars. Except for the northern path, all the altars had been blackened by fire. Each path ended at the altars, except the eastern, which split and rejoined

before petering out beyond the altar. A curious carving adorned each altar: crescent- or half-moon-shaped marks with five lines added to the tip at one end and three at the other; all were oriented in different directions. The eastern path had five stones and four steps in it. Deeply cut into one of the rocks was a symbol of the rising sun. There were four stones and three steps in the western path, three stones and two steps in the southern one and only one triangular stone along the northern path.

The boundary of the circle was marked by holes placed three feet apart. Holes in the paths to the center mound were much larger than the others. Outside the circles were many ash heaps. Natives believed "that the Great Spirit once lived there; and that since his disappearance Indians sometimes went to the place to walk the paths which God once trod, and then hastened away, as He had done, without leaving a trail to show which way they went."

Jordan Clark and Jacob Bankston made the first recorded visit to the site. They had a description of the area, but there were no established trails leading there. On April 22, 1783, they found river shoals and knew they had reached their destination, a land of towering forests full of birds and other game animals. The native inhabitants were horrified when the Americans shot and cooked a bear for their supper. Violence against any being was forbidden there, including hunting, and when warring bands met at Yamacutah, they were friendly until they departed this holy sanctuary.

The complex had "many other mysteries which will never be fully explained," Jackson recorded. Although the country looked pristine, the "paths were as smooth and clear as a parlor floor," surrounded by neatly trimmed cane.

Clark and Bankston left but returned in June 1784 with settlers to organize a community named Yamacutah, or Tumbling Shoals. Events of the following year made some, settlers and natives alike, wonder if the transaction was approved by the Great Spirit. In May, a severe freeze fell on the region, killing large trees, freezing fish in ice and killing wolves and panthers. That remarkable event was followed by a day of darkness on November 24, when the sun shined but cast no light or heat. People spoke in whispers, and animals wandered about in a confused state. Native Americans were particularly disturbed. A multitude arrived and sat around the sacred circle all day and night, staring at the carved statue. When the sun rose the next morning, all rose and walked the eastern path before disappearing in the distance.

In 2014, Mrs. Louise Maddox was an eighty-seven-year-old Jackson County resident. She described seeing Yamacutah in 1939 to the Indigenous

People's Research Foundation (IPRF). An aunt had taken her to an old wooden bridge within sight of the ceremonial complex. She saw the circle, the large statue and several smaller carved wooden artifacts that stood amid the circle. The aunt would not allow Maddox to approach the area because it was still considered sacred, even to whites a century after settlers arrived. This belief was confirmed by Wilson in his *Early History of Jackson County*. He wrote that for more than "a generation no road" led to the site of Yamacutah.

Most importantly, Mrs. Maddox revealed that one of the stone monuments still existed. When the Native Americans were removed in the 1830s, her great-great-grandfather William Williams, himself descended from the Cherokees, removed the artifact from Yamacutah and brought it to his family's property for protection. The invaluable statue remained in the family for 150 years, eventually passing into the possession of Mrs. Maddox. Its location was known to few, but Maddox took an IPRF team to the object. She authorized IPRF to "recover and preserve" the artifact, and in September, she donated it to the foundation.

The statue is a large monument, a two-hundred-pound piece of quartz, still retaining baked-on clay and colored pigments, including blue (the statue had probably been painted). No one knows the fate of the other carved stones and wooden images from Yamacutah.

THE GEORGIA ELEPHANT DISC

Considerable evidence of pre-Columbian contact with old-world cultures has been discovered across Georgia.

Around May 1973, Tom Hill Davis Sr. and his son, Bubba (Jr.), were net-dragging a ditch near Jones Creek on U.S. 301 five miles north of Ludowici, in southeastern Georgia, for crayfish. They had not expected to recover a small clay disc four centimeters in diameter.

The artifact came to the attention of Georgia biologist and archaeologist Dr. Clyde Keeler of Georgia College and State University in Milledgeville. He and Davis Jr. coauthored a presentation about the item for delivery at an Epigraphic Society (which studies inscriptions as writing) symposium at Columbus in October 1979. Advancing along the edge of the disc are eight tiny Asian elephants; between them are rectangles that resemble writing symbols from Southeast Asia. In the center are wavy lines, a near-universal sign for water. This artifact is actually a negative—the symbols

are sunken, so that when pressed on wet clay, sharp, raised characters are left on the ceramics. This was a common method Native Americans used to decorate pottery.

In Hindu tradition, where the first elephants could fly, children were told that thunder was the sound of trumpeting elephants in the sky. Lore also has elephants trampling serpents, which prevented rain from falling. This artifact may have been a talisman for rain.

Of course, elephants did not exist in the last few thousand years in America, but at least five elephant effigies have been located in Mexico; others were found in Ecuador and even Oklahoma. Elephants obviously meant a great deal to some of our ancient tourists.

PUNIC INSCRIPTION FROM HARTWELL

Atlatls were used by ancient Native Americans long before the invention of the bow and arrow to propel a spear and increase its range and force. Atlatl weights, also called banner stones, were often butterfly shaped.

In November 1956, George Stowe, his brother and their father were at a Native American site in Hartwell, in northeast Georgia, when they found a banner stone and a black stone celt in an area where more than 1,500 projectile points had been collected over the years. One side of the atlatl bore an inscription. After a Cherokee expert determined that it was not Native American writing, the artifact was brought to the attention of Dr. Joseph B. Mahan of the Columbus Museum, who referred it to another expert in ancient script, Dr. Barry Fell, a Harvard zoologist and expert in epigraphy.

Fell found that "the inscribed letters [were] extremely weathered and the patina suggests a considerable age." He identified the script as a degenerate Punic of the second century BC and meant "javelin-caster." At this time in world history, Rome had destroyed Carthage, causing many of the defeated to seek refuge in foreign lands, including North America. Fell believed that "some Punic speaker came to America in the second century BC, observed the use of the weapon unfamiliar to him and obtained and labeled a specimen."

ANCIENT AFRICAN GORGET AT ETOWAH

In late October 1983, a symposium on American history before Columbus was hosted by Dr. Mahan. As a field trip, he escorted thirteen members of the Epigraphic Society to tour the Etowah Indian Mounds at Cartersville. While inspecting artifacts in a glass case, Gloria Farley, an early leader of the Before Columbus movement, spied a shell gorget, fashioned as a decoration, which depicted two men holding right hands and wearing square headdresses. Inscribed on the two figures was a line of script that Farley identified as using a Numidian alphabet, developed in ancient Libya. Her colleagues agreed, and the artifact was photographed.

Barry Fell determined that the language was Berber-Arabic and translated it as, "A disk to give pleasure, a religious artifact of good omen to lead by the right hand." The artifact was classic Native American but influenced by Berber Numidians from Africa.

ANCIENT ROMAN COIN

In the *Monticello News* of September 11, 2014, Janet Jernigan related an interesting historical incident with its origin forty years ago. She lived in a small town outside Savannah that relied on septic tanks for sanitation. However, they lived so close to the Intracoastal Waterway that their sewage threatened to pollute the channel.

Janet's family hired a plumber to excavate a ditch for the pipe that would tie the house into the county sewage system. Janet was chatting with the man while he dug into the sandy soil. "He threw a shovel full of dirt up on the edge, and I looked down to see something shiny," she wrote. "I picked it up and it looked like a coin from maybe a child's game. Neither of us knew what it was. I just thought it was pretty and put it in my jewelry box."

Fast-forward thirty-five years to 2007, when Janet searched the Internet for "coins and coin collections." What she found "nearly knocked me out of my chair. There was a picture of a coin exactly like mine." Janet found two coins identical to hers—one held at Lawrence University in Appleton, Wisconsin, and the second at the American Numismatic Society Collection in New York City. "The coin is a silver denarius minted between 29–27 BC and commemorates the naval victory of Octavian, also known as Caesar Augustus, grandnephew of Julius Caesar, against

Octavian's rivals, Marc Antony and Cleopatra of Egypt," which occurred on September 2, 31 BC.

Seeing Antony's fleet in trouble, Cleopatra decamped for Egypt, followed by Antony. There both killed themselves. "On one side of the coin, you see Victory, standing on the prow of a ship, holding a wreath in her right hand and a palm in the other. On the obverse, you see Octavian, Caesar Augustus, riding in a chariot, holding an olive branch in one hand and the reins of four horses in the other. Below is 'IMP.CAESAR' standing for Imperator Caesar. He was declared the first emperor of the Roman Empire."

The Sprayberry boulder in Marietta contains three types of carvings, concentric circles, cupules and soapstone bowl scars that date back three thousand years. *Earline Miles.*

Janet searched for a reason why the ancient coin came to be deep in the soil of coastal Georgia two thousand years after it was minted. She learned that beginning in colonial times, English ships were loaded with ballast weight, consisting primarily of stone, for the journey to America, after which the stones and attached dirt were discarded and cargos of raw materials were loaded, bound for European factories. This practice continued for hundreds of years. "Savannah used the ballast for road beds and building projects."

The coin was found beside an old roadbed, with the material perhaps brought there from the port. Of course, another possible explanation is that ancient travelers brought it with them to America on a trade mission. Dozens of Roman coins have been found scattered across America, with several located in Georgia and Alabama.

In honor of her hometown, Janet donated the coin to the University of Memphis Institute of Egyptian Art and Archaeology in Tennessee.

ANCIENT INSCRIPTIONS
AT A HOUSTON–MACON COUNTY CAVE?

"From so many sources has come a tradition of an old Indian cave, that it cannot be overlooked," wrote Louise Hay in *The History of Houston County*. Said to be located in the soft limestone on the old Davis Place were "two entrances to an enormous cave." Beside the entrances "are huge boulders, on which are carved forms of Indians and many hieroglyphic looking markings." Three miles away, at the Shannon Place, there was yet another opening. "These subterranean channels have been followed in recent years and undoubtedly connect, and the story goes that when the Indians were hard pressed they entered these caves, disappeared and emerged at an opening close to Montezuma on the Flint."

Another source of the story was Cilla Kirkley, a Creek Indian who moved to Quitman from Montezuma when the Native Americans were forcibly removed to Oklahoma. Kirkley told another Quitman resident, Grace Gillam Davidson, of a cave near Montezuma along the Flint River. She lived four blocks below the trestle between Montezuma and Oglethorpe and said the cave was nearby. She also described how her people used the cave as an escape tunnel.

There seems to be some supporting evidence of this cave and the stone markings. In the fall of 1973, Steve Johnson and his son, also named Steve, of Oglethorpe, met Dr. Joseph Mahan in Westville at a conference dedicated to the idea of ancient pre-Columbian contact with Georgia. The Johnsons had discovered a cave near their home along the Flint River, presumably the legendary site then associated with stories of treasure, a long tunnel, Native Americans and fugitive slaves.

At the entrance to the cave were two flat stones with inscriptions. The Johnsons mailed sketches of the characters to Dr. Mahan, who replied, "I believe they are indeed ancient letters." However, in August 2006, John Trussell and Stephen Hammack of the Ocmulgee Archaeological Society searched along the Houston-Macon line in search of caves and petroglyphs. They found two small caves, only one large enough to enter. "We found no petroglyphs," Trussell wrote, "but did see graffiti outside the cave," probably dating to the nineteenth or early twentieth century. "Despite local legend, no underground passages to Montezuma were discovered."

Sprayberry Petroglyph Rock

A few speculative amateur archaeologists find messages from pre-Columbian old-world explorers on every petroglyph in Georgia. Of course, Native Americans were responsible for the vast majority of our rock carvings.

Atlanta's most accessible petroglyph is Sprayberry Rock, located outside a Wells Fargo Bank at 2687 Sandy Plains Road in Marietta. The boulder was moved one hundred feet for construction and is easy to visit.

Sprayberry Rock, made of soft soapstone, features three types of carvings dating from 3000 BC. The oldest are scars left by the manufacture and removal of soapstone bowls, which were traded throughout the East and Midwest. Six bowls were carved out of the boulder, while a seventh, partially formed, was left attached. The second type of carvings are cupules, or nutting holes, thought to facilitate the processing of nuts and acorns for food. More than a dozen dot Sprayberry Rock. Finally, the true petroglyphs are a number of engraved concentric circles at one end of the boulder. Despite extensive speculation, their meaning remains a mystery.

Medicine Men Must Get Stoned

Tommy Hudson spent years studying Georgia's petroglyphs. Within a pocket cave on a bluff in northern Georgia is the Witch's Nest, Georgia's most important petroglyph site, carefully protected from vandals by the same family since 1848. More than 90 percent of the carvings are entoptic iconographic designs, probably made by shamans. According to Hudson, these ancient priests would, "through various rituals, contact the spirit world in order to communicate with ancestors, influence the weather, improve the hunt, foretell the future, cure the ill, and place spells on their enemies, among other things," he wrote in *The Profile*, newsletter of the Society for Georgia Archaeology.

To accomplish this, they "would often enter trance states in order to contact the spirit world. In order to put themselves in a trance, they would deprive themselves of sleep or food, participate in long hours of sensory manipulation, such as by singing, dancing, drumming, or deprive their senses altogether by staying in a dark place. The quickest way to achieve a trance state has been to take drugs that alter a person's state of consciousness."

During the first stages of trance, shamans witnessed bright geometric designs created by electrical impulses inside the optic nerve. The vision seekers would then experience hallucinations, including journeys through tunnels, the feeling of flight and transformation into animals. The most common petroglyphs appear to originate from these altered states of consciousness.

ASSORTED STRANGENESS

ASTRAL PROJECTOR

This story I gleamed from a book titled *The Phenomenon of Astral Projection* by Sylvan Muldoon and Hereward Carrington, initially published in 1951 and most recently reprinted in 1981. Georgia's astral projector story is found in a chapter titled "Projections at the Time of Death: Witnessed Projection of Dying Person." The case was first published in the *Journal of the American Society for Psychical Research* in 1915. It is recorded as "The Sargent Case" for the narrator and "principal percipient," Mrs. Margaret Sargent, a certified nurse. Sargent worked in Augusta, and the date was described as "some years ago."

Sargent and a doctor were sitting with a woman who had a stubborn fever. At 11:00 p.m., "disquieting symptoms developed." The girl's mother slept in the next room, but the doctor was reluctant to wake her for fear that exhaustion would imperil her health.

Doctor and nurse knew that the daughter wanted her mother present but believed that was unnecessary since their patient was unconscious. "The final symptoms were not long in beginning," Sargent recorded, "and we were awaiting death." The two remained faithfully by the patient's side:

> *I was sitting at the foot of the bed, silently watching the poor dying young woman, whose breast had ceased to move....*Suddenly, from the head

of the bed, I saw a white form advancing, *a robed form, although I could not see the face, because it was turned in the opposite direction. The form remained for a moment by the inert physical body, then passed swiftly past the doctor and glided toward me, but always turning its face in the opposite direction.*

It entered the room of the sick woman's mother. I was stupefied, and at the same time had an inhibition that kept me from moving or speaking. I could not understand how the form passed through the wall.... *At the moment the phantom passed the doctor he exclaimed, "Something struck me on the shoulder!"*

"Yes," Sargent replied, "the woman just went past you."

"What woman?" he exclaimed. "I saw no one. But someone struck me. What does this mean?"

As they stared at each other, they were shocked "by the feeble voice of the sick girl," who was suddenly conscious. The young lady lived another day, dying in the arms of her mother. Nurse and doctor believed that "at the time when death was imminent, the soul of the young girl, who idolized her mother, left its own body for the moment to make its adieux and then returned to its own again."

The burial mound at Ocmulgee National Monument in Macon. A dowser convinced Dr. Arthur R. Kelly to allow him to dowse for bones. *Earline Miles.*

Sargent added that if one rejected a case of astral projection in this instance, then it was obvious "that a *spirit* was manifested to us that night," a spirit that she saw and which had struck the doctor. Sargent's theory was "that the *desire* of the dying girl to be with her mother, caused her to be projected to her, and that the blow which the doctor received was in vengeance for his refusal to summon the mother at the girl's request."

The doctor, respected in the local medical community, added to the article, "I am the doctor referred to in the above story and I certify without hesitation that it is absolutely correct." His name was not revealed. This was my first Georgia astral projection case.

THE DOWSER AT OCMULGEE NATIONAL MONUMENT

Dr. Arthur Randolph Kelly, born in Texas in 1900, became one of America's most respected archaeologists. After receiving a PhD in anthropology from Harvard in 1929, he was hired by the Smithsonian Institution to excavate the Ocmulgee site in Macon, where he dug with up to one thousand Works Progress Administration laborers. Kelly started the Department of Anthropology at the University of Georgia in 1947 and was its chairman and a professor.

A series of conversations between Dr. Kelly and Woody and Mark Williams was taped and the transcripts published as "Ramblings with Kelly," edited by Mark Williams, in *LAMAR Institute Publication 7* in 1990.

During World War II, Kelly, superintendent at Ocmulgee National Monument, was manning the museum alone one Sunday afternoon. Bored, he read the newspaper, his feet up on a desk. There had been no visitors. Suddenly, "You know, you're sitting there and you have a sort of eerie feeling that someone's looking at you," Kelly said. Looking up, he found a "mousey looking man…very hesitant manner," standing there. This individual had just "slipped in and didn't say a thing."

Kelly invited the man to speak. "And he wanted to ask me a question, and he was evidently having a little difficulty about it. And finally he sort of blurted out. He asked me if I believed in dowsing." Kelly said he had no experience with dowsing, but that his geologist friends believed "there wasn't anything to it scientifically." Why, he asked?

"I can use the dowser and find bones," he man said.

Kelly took his feet off the desk and gave the visitor his complete attention. "You can do what?" he asked.

"I can find bones. Human bones." Kelly asked if he could distinguish between human and animal bones. The answer was yes. Kelly's face apparently betrayed his skepticism. "I've done it," the visitor declared.

The stranger said he had solved "a number of murders" and found missing bodies. At a deep spring pool in South Georgia, he had told police where a drowned person could be found. They dove and located the body where he had directed them. In another case, the police suspected a man had been murdered and buried beneath a haystack. "And there were a hell of a lot of hay stacks." He literally found the body in the haystack. Finally, he had located every grave in a colonial cemetery that had no markers.

The man asked if there were bones at Ocmulgee. Kelly had spent five years excavating the site and found many bones, but he admitted that the entire site had not been excavated, so certainly there were bones still there. The man "brightened up at that."

"We've got the afternoon if you're not busy," the man said. "I'd like to demonstrate."

Kelly didn't expect further visitors, and "this sounded like it might be interesting, so I said, 'Sure, let's go.'" Outside, the man cut off a tree branch and trimmed it to his satisfaction, and then Kelly "just let him go where he wanted to." The archaeologist knew where he had and had not excavated, so "I really got advantage of him," Kelly thought smugly.

For more than an hour and a half, the man dowsed areas that had been thoroughly excavated. "He never gave any sign" of a discovery, Kelly said. "He hadn't bobbled once" and "was beginning to look disappointed."

At last, they entered an unexcavated section. "There's something here," the man announced, and twenty feet over, "There's something here." He placed a stick at every strike, twelve or thirteen burials marking a circle about thirty-five feet in diameter. "There's something funny about these bones," he told Kelly. "Were all of your burials fully extended?" Kelly had found bundle burials, and so had the dowser, but without actually seeing the remains.

Back at the museum, Kelly scratched his head and "tried to figure that one out."

"Well, aren't we going to dig and confirm this?" the man inquired. Kelly explained that he could not without a permit and considered how it would look if he requested a permit to excavate based on the testimony of a dowser. The visitor left a "bitterly disappointed man. He went away very sad, just shaking his head."

President Jimmy Carter, who saw a UFO and ghosts, accompanied his father to consult a psychic about a missing dog. *Earline Miles.*

Kelly never excavated the area. As he described the incident to his classes, students asked if he had considered going out at midnight with a shovel. "I was tempted," he admitted.

Years later, Kelly was working the Wilbanks site, where a mound was excavated, but not the village, an area of up to one hundred acres covered with two feet of alluvium sand. "I wished to hell I had that character back," Kelly had thought. "I'd try him out again. 'Cause this ought to be duck soup." The point here is that a leading archaeologist seemed to have no doubt about the accuracy of his dowsing visitor.

In the late 1970s, I attended a talk Dr. Kelly gave at Macon College. I waited outside and asked about stone mounds that had been discovered at Juliette in Monroe County. He was patient with me and confirmed my beliefs on the issue. He died several years later in 1979.

Jimmy Carter and the Fortune-Teller

One thing I love about former Georgia governor and U.S. president Jimmy Carter is his honesty, even concerning bizarre topics like his UFO sighting, the family's tenure in a haunted house and the attack of the rabid killer rabbit.

With my own roots in rural Alabama, I thoroughly enjoyed Carter's book *An Hour Before Daylight: Memories of a Rural Boyhood*. Those stories reminded me of my parents' youth on farms in the Deep South during the Great Depression.

In the book, Carter spends considerable time describing the dogs that populated his farm. "One of the worst days I remember," Carter wrote, was when a prize pointer disappeared. His father placed a bowl of water and an old hunting jacket where the dog had last been seen in the hopes that the animal would return during the night. The dog failed to show, and the entire family searched unsuccessfully for the valuable and beloved dog for several days.

With all conventional tactics exhausted, Carter's father "went to see the local fortune teller" to see if the psychic could determine the whereabouts of the wayward canine. Jimmy was allowed to accompany his father. "She had a sign in front of her house covered with heavenly bodies and a large hand, with lines in the palm indicating issues of importance: life, death, wealth, love."

Former president Jimmy Carter's family consulted a local fortune-teller in an attempt to find one of the farm's wayward dogs. *Illustration by Sarah Haynes.*

Carter was surprised by their lengthy wait in the fortune-teller's yard, which he found "quite unusual for prominent white people in a black person's yard" in that era, but the Carters waited patiently, which may indicate the prominence of this seer.

When Carter and his daddy were allowed inside the house, Jimmy stood back while his father laid down a dollar, sat at a small table across from the psychic and described the situation with the missing pooch. "She seemed to go into a trance for a few minutes," Carter wrote, "and then said, 'Mr. Earl, you ain't never gon' see that dog ag'in.'"

Carter concluded the story with, "She was right." I personally believe that when the Carters left, the fortune teller giggled, having accurately

played the odds at how often dogs returned home after being gone for such an extended period. I don't really believe in psychics, but I do admire their showmanship.

ELVIS AFTER LIFE: A REMARKABLE TALE

Dr. Raymond A. Moody Jr. came to prominence in the 1970s by relating life-after-death reports gleaned from patients who described their experiences after brief periods of death. The book, *Life After Life*, and the field of near-death experiences are still controversial, but Moody was not dissuaded and has written other books on this and related topics.

In 1987, Dr. Moody wrote another provocative book, titled *Elvis After Life: Unusual Psychic Experiences Surrounding the Death of a Superstar*. It is an interesting little tome (check Amazon for a cheap copy), particularly the sixth chapter, "In Search of a Son with Elvis."

By 1982, Harold Welch had served as a policeman in a small Georgia city for fifteen years. Welch, "a large, tough-looking man," was "surprisingly gentle and soft spoken," the doctor wrote. Moody found it difficult to think of him "having an uncanny psychic experience," but he "had the distinct impression that he was describing events just as he remembered them."

Welch raised four sons, but only Tony gave him trouble. The teenager joined the wrong crowd, drank, took drugs and shoplifted. When his grades dropped, arguments occurred regularly. In early February, Welch "said some things I shouldn't have," and Tony stayed in his room playing records. Tony "liked Elvis Presley," Welch stated, "always Elvis. His room was full of Elvis posters," and he "knew everything there was to know about Elvis."

Tony, who had saved more than $2,000, left for California without saying a word, hoping to make it in the movie business. As a policeman, Welch knew what happened to runaways in Los Angeles and feared the worst. Tony left on February 11, and Welch and his oldest son, Harold Jr., an Atlanta policeman, planned to fly to California on March 3.

On the night of March 1, Welch had a dream in which Elvis appeared with "information about Tony." Elvis said, "I'm worried about Tony, sir. Tony is a fan of mine. He's out there in Los Angeles, and I can't get through to him." Elvis wore regular clothes and displayed a policeman's badge. In

life, Elvis wanted to be an undercover agent and received an honorary FBI badge from President Richard Nixon. Welch had pinned a map of L.A. on the wall, and Elvis pointed at it and "tried to show me some streets in a certain area of Los Angeles." Dreams are strange things, and Welch could not focus on the map or read street names.

Elvis gave up on the map and started talking: "Look, Tony is staying in a rooming house." He conjured a scene of "a short street with a drugstore on the corner and a short-order diner across from it." Instantly, Welch and Elvis were on that street, Elvis pointing out landmarks. Again, Welch had difficulty distinguishing details, and Elvis said, "Look man, you gotta look at this. This is important man."

Welch saw an older, run-down two-story house but could not see the street's name. "Man, your son is on drugs," Elvis persisted. "You gotta get him some help." Elvis "impressed me as a concerned man," Welch said. He thanked Elvis and woke up "with a headache…but I woke up knowing that I would find Tony."

In L.A., Welch and his son contacted local police and learned of places where runaways hung out. They passed out photographs of Tony, but no one recognized him. The Welches rented a car and cruised the recommended neighborhoods. Welch was driving on March 9 when he saw the short street, drugstore and diner Elvis had showed him. He told Harold Jr., "This is where we'll find him." Welch feared that Harold thought he was insane.

Welch knocked on the door of a house that he recognized, and when an older woman answered the door, he asked if Tony Welch was there. He was, and when Welch explained that he was Tony's father, she directed him to a room upstairs, where he knocked on the door and was invited inside.

Seeing his son, "I looked right into his face and grinned. He turned white as a sheet. He said, 'Dad, how did you find me?' He burst out crying and jumped up and came over to me."

They hugged for a minute, and then Tony said, "Dad, I want to go back home."

Tony packed, and they returned to the hotel. Both sons were curious about how Welch located Tony, but their father never revealed his source, embarrassed to "tell my sons Elvis showed me the street in a dream."

In their room that night, Tony said, "Dad, it's the funniest thing. Two times since I've been out here I've had dreams about Elvis Presley. In both dreams, he told me you would be coming to get me. He said he was worried about me. He said he would work it out."

At home, Tony received treatment for his addiction and recovered. "It seems to me that Elvis Presley was worried about my son," said Harold, who believed that Elvis, concerned about Tony, "came in a dream to help." Dr. Moody considered Welch "a reliable, sincere and rational person, not prone to fantasizing."

My Father Shoots Me a Cosmic Finger

I woke up one morning and staggered into the bathroom, automatically switching on the radio. Earline, who had just left for Sunday school, had the radio tuned to a gospel station. I immediately recognized the tune as an old hymn that was the song my parents had selected to be sung at their funerals, "I'll Meet You in the Morning."

It then dawned on me what day it was. My father had died on July 17, 2001, exactly ten years before. I have a tale to relate about my father that he would find amusing for two reasons. First, Daddy did not share my fascination with the supernatural. I don't think he believed any aspect of the paranormal. Second, he was the "Bird Man." My father was a genius in flipping people off, giving them the bird by launching his middle finger. It was rarely malicious, just casual, as if welcoming a visitor or biding them goodbye with a wave or a nod. When he was amused or mildly annoyed, he would let the birds fly.

Daddy's salutes were so impressive, so sharp, that they snapped out crisply, like soldiers coming to attention. Every bird was perfectly formed and could be held indefinitely. Also, Daddy was a double birder. On special occasions, he would present two birds simultaneously. The man was an artist, and it was an honor to receive his salutations. Most everyone who ever knew my father could attest to his virtuosity.

In June 2001, my father underwent extensive abdominal surgery. It was risky, but he survived. Unfortunately, the operation revealed severe heart disease that dictated further surgery. For weeks, Daddy fought in the hospital to gain the strength necessary to survive the next ordeal. We thought he would recover until the day he died. During his last hours, my parents' oldest and best friends walked into the hospital room unexpectedly. They explained that they both felt they should come immediately.

Daddy had a heart attack after his abdominal surgery and spent days on a ventilator in ICU. Only two of us could visit at a time, and my brother Ray

and I went in to attempt to cheer him up. Of course, he could not speak, and he refused to write messages on his tablet. Ray and I did our damndest to make him smile or elicit any positive response from him, but he just stared at us. When our time was up, we attempted to excuse ourselves graciously. In response, Daddy shot us the double bird. They were the last birds I saw him present, unless you count…

A few days before Daddy died, my daughter Melanie and I had visited him at the Medical Center in Macon and started home for Warner Robins on GA 247. It was late afternoon, and the sun was touching the western horizon as Mel drove. As you come upon the Macon airport, there is a clear view of the sky to the west. Deep in gloomy thoughts, I glanced that way and spotted a single cloud. It was a unique cloud. This cloud had taken the unmistakable formation of a giant bird—not avian, but rather a human middle finger jutting out from the fist.

I was astounded. I stared at it for a moment before asking Melanie to look out my window. When she did, we nearly left the highway. The figure was colossal and finely detailed. For a moment, I thought that God was giving us the finger. I considered it a cosmic finger. The cloud maintained its position and detail until we drove into the swamps of Echeconnee Creek. The apparition left us speechless.

After Daddy died, Melanie reminded me of the cosmic finger. "That was Papa saying goodbye," she said. I thought about it and decided she was right. God wouldn't really give us the finger, I reasoned, and it was a suitable farewell from my father.

This story was not meant to be offensive, but rather an odd tribute to my father. He would have liked reading it, and then he would have flipped me off with a mischievous grin—probably with a double bird. Me personally, I can only shoot one bird at a time, and it is always sloppy and anemic. Perhaps proper birding technique skips a generation. Come to think of it, Mel is pretty accomplished.

I don't consider my family to be unusually weird, but I seem to have written a lot about us. Huh, maybe we are unusually weird.

Georgia's First Cattle Mutilations Found in Hall County

"South Hall Farmers Lose Cattle to Mysterious Mutilations."
—Gainesville Times, *October 9, 2009*

It is headlines like this that cattlemen hate but paranormal researchers live for. Mutilated farm animals, usually cattle but occasionally horses and other creatures, well over ten thousand of them, have been mysteriously killed and mutilated in parts of the United States over the past half century.

Common characteristics of mutilations include the removal of milk sacs, genitals, anuses, tongues, eyes and ears with "surgical precision," leaving no trace of blood on the animal or ground from the butchering. Sometimes the animals are completely drained of blood. The wounds are often characterized as "cored." Both male and female cattle have been victimized, and evidence of high temperatures, amounting to hundreds of degrees, has been found in some instances.

Theories include animal attacks—but there are never any tracks left and the flesh is not torn and ragged—and cultic humans, but again, there are no footprints or tire marks. UFOs or mysterious black helicopters are often associated with the crimes. In fifty years of mutilations, no individual has been charged or prosecuted in any case. The phenomenon has even gained a name: "bovine excision."

Georgia's first recorded instance of a mutilation originated in northeast Georgia in September 2009 and recurred in 2010. Kathy and John Cooper operate a 250-acre beef cattle farm in southern Hall County. They have more than two hundred cattle, and a few are expected to die, but not in this manner. In October 2009, the Coopers reached out for assistance when cattle turned up dead minus parts removed with surgical precision.

First, John found a cow with its milk sac taken out in a circle—the carcass had not decayed or been eaten by predators. Two weeks later, he discovered the carcass of a seven-month-old bull calf, its genitalia partially removed.

A visit by Hall County Sheriff's Department investigators offered no solace; an inquiry was started, but there were no suspects. "It's scary," said Kathy, thinking of someone roaming their property on such missions.

By a year later, in October 2010, the Coopers had lost twenty head, worth at least $10,000 since breeding cows were involved. "They don't leave blood or anything," Kathy said. "It's almost like a surgical cut."

Well over ten thousand farm animals, usually cattle, have been mysteriously killed and mutilated in parts of the United States over the past half century. *Illustration by Sarah Haynes.*

When seven cattle died in May, veterinarians concluded that one had been poisoned, although they could not determine by what. The animals are usually found in wooded areas or ravines, not in open pastures, and when they are found by the smell of decay, it is too late to determine a cause of death.

There are still no clues or suspects, and the investigation is ongoing. "It is very bizarre and very unusual," said Colonel Jeff Strickland of the Sheriff's Office. "We've had no incidents in the adjoining pastures owned by different people."

Part of Kathy's distress is caused by the sheer waste; seven-hundred- to eight-hundred-pound cattle were being sacrificed, with only a few parts removed. "That's all they cut off," Kathy stated, and this is the obvious reason for the killings. No footprints or tire tracks have been found, but their latest loss, a five-year-old pregnant cow with its udders and genitals removed, left the first evidence. "You could see where they went in there on their knees and elbows and lifted her tail up and just cut it off," Kathy said. "That's the first sign of any kind."

The latest round of mutilations drew national attention, with publicity on Atlanta TV stations, CNN and the *Coast to Coast* radio show. Ideas poured in from research scientists and investigators. A dog was purchased to alert the Coopers to trespassers on their property, and a reward was offered for information leading to the arrest of a culprit, or culprits. If another animal were killed, veterinarians would immediately be called in to conduct a necropsy and gather evidence before it degrades. A deputy was dedicated

to the case, but most of the calls received related to the paranormal or extraterrestrials. "They believe it's got to be something other than humans," Cooper noted.

These measures may have frightened off those responsible, or perhaps the perpetrators had completed their work, for no additional cattle have been victimized. The paranormal or extraterrestrials may have been responsible, but even a human agency has chilling implications. What psychosis could feed a need to commit such acts and for what purpose were the removed organs used? Human motivation could be more puzzling than the weirder alternatives.

THIS LITTLE PIGGIE

McCaysville is a small mountain town located just inside Georgia at the Tennessee border. Ellen Lee lives there on thirty-eight acres with a husband, two children, twelve horses, thirty sheep, two donkeys, twelve dogs, fifteen cats and nine pigs—strike that, eight pigs—and that is the story.

The missing pig, named Halle Berry, ten months old, was a house- and leash-trained porker. The pet pig enjoyed belly rubs and eating Lydia's hostas. In early November 2006, some despicable cretin pignapped Halle and then killed and butchered her, leaving the carcass on Ellen's land. "Every morning at breakfast and every evening at supper I think, 'Are they cooking Halle?'" she told Jennifer Brett of the *Atlanta Journal-Constitution*. "She was more than the price of bacon or sausage. She was a family member."

Ellen was infuriated by the murder of her prized pig. Weaver reported the crime to the Fannin County Sheriff's Department and offered a $1,000 reward for information leading to the capture of the porker killer. Such a crime, while upsetting to the owner, is not likely to receive a great deal of police attention. The act, animal cruelty, is a misdemeanor, bearing a penalty of up to a year in jail and as much as a $5,000 fine. This animal was obviously butchered for food, but aggravated animal cruelty, involving torture of the creature, can bring five years in prison and a $15,000 fine.

These facts led Lee to consider alternatives to a traditional police investigation; she wanted to hire a psychic to seek out the perpetrators. A sheriff's officer "sort of smirked" when she raised the issue, Ellen said, and the Fannin County Sheriff's Department refused to comment. Undeterred, Lee engaged the services of Dot Bridges, who can communicate with the

deceased, apparently human and animal alike. "I have never called a psychic in my life," said Ellen, "but I am desperate."

Bridges bragged, "I can see spirits and communicate with sprits." She is a Jasper resident, volunteers to rescue animals and locates homes for pigs that have outgrown their owner's capacity to care for them. Bridges was soon receiving psychic information about Halle Berry. For starters, Halle had not suffered. "She felt a sting in her neck," Bridges related. "Then she was with her mother."

Bridges had not known that the pig's throat had been cut or that the mom had predeceased her offspring, dying shortly after Halle's birth. Bridges sensed that there was more than one person involved in the pigacide and that Halle had been stored before her return to Lee's land. "I see a freezer," Bridges averred. Bridges apparently believes in a hog heaven, saying, "I'm so upset about it, but I also know she's in a good place."

As to the person who committed the act, "Somebody that could do that is the epitome of evil," Bridges said. "When I had an image of him, it just made me shake."

Bridges, daughter of a minister, honed her psychic skills in many tent revival meetings. She considers herself more spiritual than religious. "I believe if you ask God for help, you'll get it." Bridges expects help from sources other than the paranormal, believing that the criminals would tell others about their acts. "Even if we don't get justice in this lifetime," she concluded, "we will in another."

THE CONFEDERATE AIR FORCE

Charles C. Cevor, an engineer for the Central Railroad, dabbled in early balloon flight. In February 1860, he advertised in the *Savannah Daily Morning News* a "free exhibition" of what he called his "monster balloon," grandly named "Montpelier." It would be launched from the Armory Grounds on March 8, 1860, filled with coal gas.

Just after 5:00 p.m. on the appointed day, Cevor took off, blowing kisses to the cheering crowd while Mr. Dalton, a companion, waved an American flag. The "Montpelier" soared above the city, crossed the Savannah River near the lower rice mill and was taken by another air current toward Tybee Island. Alarmed, Cevor threw out a grappling hook. It snagged a tree, but the cable broke and the balloon was eastbound again, disappearing from sight

toward the Atlantic Ocean. Cevor then took drastic measures, descending his balloon into Calibogue Sound off Hilton Head, South Carolina.

A plantation overseer named Sawyer rescued the aeronauts. Once the men were secure, an effort was made to recover the "Montpelier," which broke free once more and took flight, "away to the clouds," reported the newsmagazine *Harpers Weekly*, "in a region where the eye could not penetrate, to the home of balloons alone." One reported sighting arrived from along the Suwanee River in Florida.

Cevor and Dalton spent the night at Sawyer's house and then boarded the steamer *Cecila* at Bluffton and returned to Savannah on March 12. Cevor went immediately to work on another balloon, using the newspapers on April 26 to thank the citizens of Savannah for providing funds for his new device, called "Forest City," being constructed at E.W. Buker's storeroom.

On June 22, the *Morning News* announced that the "Forest City" would fly from the Barracks Yard for a fee of fifty cents per spectator.

Georgia seceded from the Union on January 19, 1861, and joined the Confederacy. On April 11, 1862, Savannah was alarmed when Union forces sized Fort Pulaski at the mouth of the Savannah River. On May 31, a Confederate army balloon was to be deployed to scout the Federal works, but a "most melancholy accident," according to a paper, occurred, killing William Harper and Martin Brennan, members of the Oglethorpe Siege Artillery, at the coal works.

After this disaster, another Savannah balloon was designed and constructed by Dr. Edward Cheves, at his own expense, at the Chatham Armory. Cheves enlisted a crew consisting of Charles Cevor, who was a Confederate private promoted to captain, and Private Adolphus E. Morse, of the Chatham Artillery, both recorded as "detailed for special service."

Due to a lack of white silk fabric, Cheves purchased bolts of silk dress fabric of various colors from stores in Savannah and Charleston, sewed them together and varnished the balloon to make it airtight, thereby creating a colorful aircraft. A legend started that the silk dresses of patriotic Confederate ladies had been gathered from across the South to construct the craft, giving it the popular name the "silk dress" balloon, officially christened "Gazelle."

The balloon was transported to Richmond, Virginia, in the spring of 1862, where it was filled with illumination gas (made from coal and used to light city streets and buildings) at the Richmond Gas Works. It was then secured to a train car and transported to the battlefields of Seven Pines and the Seven Days, part of the Peninsular Campaign. It may have first

been utilized at the Battle of Gaines's Mill. The balloon made numerous ascents so that Edward Porter Alexander, a well-known Confederate artillery commander, could scout Union troop dispositions and movements in battle. Imagine soldiers on both sides gazing at the colorful device bobbing in a bright sky.

The Confederate military next decided to inflate the "Gazelle" in Richmond and tow it up the James River tied to the armed tugboat CSS *Teaser*. Unfortunately, on July 4, 1862, the *Teaser* encountered Union ships, ran aground and was captured by the USS *Maratanza*. The balloon crew managed to escape.

The "Gazelle" was presented to Thaddeus Lowe, head of the Union balloon effort, who had it cut up, the pieces distributed as souvenirs. One swatch was donated to the National Air and Space Museum by Lowe's descendants.

With the loss of "Gazelle," Cevor immediately started construction of a new balloon in Savannah. It was late July 1862, and over the next few months he spent $1,175.57 on materials. This airship, with no recorded name, operated above Charleston, watching the Federal blockading fleet and land operations against the city. Cevor thought that he could see ten to twelve miles while aloft.

The balloon was operating in March 1863 when it was filled with 25,500 cubic feet of gas, which cost $102. Confederate commander P.G.T. Beauregard wanted an engineer officer aboard to chart Federal fortifications being constructed, but it is unknown if that occurred. Records are sketchy, but it seems this balloon was lost during a storm in early November 1863, putting an end to the Confederate air force.

THE CONFEDERATE SUBMARINE SERVICE

I have always been proud of the first successful submarine, the CSS *Hunley*, because it was manufactured in the city of my birth, Mobile, Alabama. That vessel was shipped via railroad across Georgia to Charleston, where it sank after destroying the USS *Housatonic*, a Federal warship. That craft was responsible for the accidental deaths of several of its own crews before its combat mission.

I was amazed to learn that a prototype undersea boat was actually constructed in Savannah. The paltry details are related by James Kloeppel

in *Danger Beneath the Waves* and in Mark K. Ragan's *Submarine Warfare in the Civil War.*

Because the Confederacy lacked a proper naval force, in late 1861 and early 1862, military authorities and civilians in ports across the South were designing and constructing ironclad warships and submarines to protect coastal cities from Union attack. One such device was produced in Savannah by Dr. Charles G. Wilkinson and Charles Carroll. On the morning of February 22, 1862, the men placed their experimental submersible into the Savannah River at the foot of Montgomery Street and boarded it through a tiny hatch. It is thought that an air valve malfunctioned, and the test ended in disaster.

Two days later, the *Savannah Moring News* reported:

> *Lamentable Accident. Yesterday an experiment that was being tried for the benefit of the Confederacy, and which two brave men, Dr. Wilkinson and Mr. Charles Carroll, had experimented, resulted in a misfortune, in which one of the gentlemen engaged lost his life. The chain of a crane upon which the instrument was suspended gave way, and Dr. Wilkinson, the investor, lost his life. Mr. Carroll miraculously escaped, after having urged Dr. Wilkinson to make his escape. We commend to the Confederacy the patriotism of these men, who were doing nothing for profit, but simply for the benefit of the cause in which they were engaged, and we are proud to state, that they were both Irishmen. Dr. Wilkinson leaves an only daughter, and we hope and trust that the people of the Confederacy will not allow her to suffer in a pecuniary point, although we know that nothing can replace an honored, loving, and devoted father. At some future period we shall explain more fully everything relating to this sad occurrence.*

Unfortunately, the newspaper was unable to provide follow-up details, and there is no known additional information about the device. Wilkinson, at forty-nine years old, was the first casualty in the fledgling Confederate submarine service. What happened to the submarine is unknown. As Kloeppel wrote, that craft "remains shrouded in mystery."

BIBLIOGRAPHY

Albany Patriot. July 1845.

Ancient Origins. "Rediscovering Yamacutah, a Sacred Monumental Site Once Lost to the Pages of History." June 9, 2015.

Atlanta Constitution. August 27, 1894.

———. "A Curious Phenomenon." March 21, 1890.

———. "A Fish with a Snake's Head." May 26, 1891.

———. "A Ghost in Goosepond." May 27, 1889.

———. "Ghosts in Laurens." December 9, 1882.

———. "Gigantic Ghost in White." October 10, 1889.

———. "Life in Georgia." August 18, 1882.

———. October 18, 1993.

———. "Rain for Four Days on One Spot." March 26, 1897.

———. "A Strange Animal." February 11, 1895.

Bell, LeAnne. "Nordoroc: Preserving a Mysterious Link to the past." *Winder Press,* November 23, 1999.

Bensonhaver, Aaron. "Experts: Windsor Haunted." *Albany Herald,* September 21, 2006.

———. "Ghosts Hunted at Historic Windsor." *Americus Times-Recorder,* August 14, 2006.

Best Western Plus Windsor Hotel. "Ghost Stories." http://www.windsor-americus.com.

———. "History." www.windsor-americus.com.

Blue Willow Inn. "Our Story." http://bluewillowinn.com.

Brunswick Times. March 27, 1950.

Bulloch Times. October 10, 1895.

Carter, Jimmy. *An Hour before Daylight: Memories of a Rural Boyhood.* New York: Simon & Schuster, 2001.

Chitwood, Tim. "The Art of Mystery." *Columbus Ledger-Enquirer*, September 11, 1996.

Claxton Enterprise. March 29, 1984.

Collins, Gene. "Many Say Windsor Haunted." *Americus Times-Recorder*, January 28, 2007.

Covington News. October 13, 2010.

Davis, Betty. "Case #081206." The Big Bend Ghost Trackers, August 12, 2006.

Davis, Bubba, and Clyde Keeler. "The Georgia Elephant Disk." *Occasional Publications of the Epigraphic Society*, vol. 8 (n.d.).

Denton (MD) Journal. October 5, 1889.

Dublin Gazette. December 5, 1882.

Duffey, Barbara. *Banshees, Bugles and Belles: True Ghost Stories of Georgia.* Berryville, VA: Rockbridge Publishing Company, 1997.

Emert, Jennifer. "Medium Helps Find Missing Turner County Man." WALB TV News.

Fall, Berry. "A Punic Inscription on an Atlatl-Weight from Georgia." *Occasional Publications of the Epigraphic Society*, vol. 18 (n.d.).

Farley, Gloria. "Ancient Writing from Etowah Mounds." *Occasional Publications of the Epigraphic Society*, vol. 11 (n.d.).

Farrell, Carly. "Ghost Legends of the Windsor Hotel." *Americus Times-Recorder*, October 27, 2005.

41WMGT. "Ghost May Haunt Sandersville's Old Jail Museum." October 31, 2012.

Georgia Before People. "The Mysterious Nodoroc Site in Winder, Georgia." https://markgelbart.wordpress.com/2013/01/09/the-mysterious-nodoroc-site-in-winder-georgia.

Giddens, Tharon, ed. "Phantom Folklore: The Mystery of the Blue Willow Inn." *Covington News*, October 27, 2010.

Godfrey, Linda S. *Hunting the American Werewolf.* Black Earth, WI: Trails Media Group, 2006.

Gurr, Stephen. "South Hall Farmers Lose Cattle to Mysterious Mutilations." *Gainesville Times*, October 9, 2009.

Hall, Kristi. "Haunted Hot Spots." *Lakelife* (Fall 2008).

Hardinge, Emma. *Modern American Spiritualism.* Charleston, SC: Nabu Press, 2010.

Haunt Analyst. "Blue Willow Inn." 2010. http://www.hauntanalyst.com/bluewillowinn.html.

Hawkinsville Dispatch. July 29, 1875.

Hay, Louise. *The History of Houston County, Georgia.* Baltimore, MD: Clearfield, 1998.

Hebert, Katelyn. "Spooky Local Stories, Legends and Lore." *The Colonnade,* October 22, 2010.

Hembre, Taylor. "Essie English: Death and Hauntings." *Sandersville Scene* (September/October 2016).

Henson, Paige. "Middle Georgia Ghostly Sampler." *Macon Magazine* (November/December 1989).

Hudson, Tommy. "The Witch's Nest: Is This the Most Important Rock Art Site in the World?" *The Profile,* no. 107 (Summer 2000).

Jernigan, Janet. "Ancient Roman Coin Found." *Monticello Times,* September 11, 2014.

Joiner, Sean. *Haunted Augusta & Local Legends.* Plantation, FL: Llumina Press, 2003.

Joseph Mahan Collection. Columbus State University Archives, Columbus, Georgia.

Kelly, Hulda K., comp. *I See by the Papers, 1899–1946.* Statesboro, GA: Bulloch County Historical Society, 1984.

Kloeppel, James. *Danger beneath the Waves: A History of the Confederate Submarine.* Orangeburg, SC: Sandlapper Publishing Company, 1992.

Lewis, Austin. "Investigators Look for 'Ghost' in Sandersville." 13WMAZ, August 12, 2012. sandersville.13wmaz.com/news/news/74238-investigators-look-ghost-sandersville.

Lost Souls Paranormal. "Old Jail Museum Investigation Sandersville GA." YouTube, https://www.youtube.com/watch?v=bt5jnMwkyE8.

MacGregor, Rob, and Trish MacGregor. *Aliens in the Backyard: UFOs, Abductions, and Synchronicity.* Hertford, NC: Crossroads Press, 2011.

———. *Beyond Strange: True Tales of Alien Encounters and Paranormal Mysteries.* Hertford, NC: Crossroads Press, 2017.

Macon Telegraph. May 27, 1829.

Madisonian. October 25, 1973.

Marshall, Brooks, Ida Lyon and Clara Neil Hargrove. *The History of Macon, 1823–1949.* Lyons, GA: Marshall & Brooks, 1950.

Milledgeville Statesmen and Patriot. July 18, 1829.

Millikin, Paul. "In Search of the FOX 5 Atlanta Civil War Ghost." FOX 5, October 31, 2016. http://www.fox5atlanta.com/good-day/in-search-of-the-fox-5-atlanta-civil-war-ghost.

Minor, Elliott. *Columbus Ledger-Enquirer*. N.d.

Moody, Raymond A. *Elvis After Life, Unusual Psychic Experiences Surrounding the Death of a Superstar*. Atlanta, GA: Peachtree Pub Ltd., 1987.

Muldoon, Sylvan, and Hereward Carrington. *The Phenomenon of Astral Projection*. London: Rider & Company, 1959.

Mutual UFO Network (MUFON). "Large Object Seen Hovering Over Tree." April 28, 2001.

————. "Possible Alien Abduction in Georgia." January 11, 2013.

Murray, Amelia Matilda. *Letters from the United States, Cuba, and Canada*. New York: G.P. Putnam & Company, 1856.

Newnan Advertiser. July 15, 1896.

New York Spectator. April 9, 1830.

New York Times. March 1, 1883.

————. "Voodooism in Georgia." June 21, 1888.

Osinski, Bill. "Landmark's Tenants Can't Shut Door on Milledgeville's Past." *Atlanta Journal-Constitution*, November 12, 2000.

Page, Jan Doolittle. "Old Newspaper Articles." http://www.angelfire.com/weird2/georgia/page12.html.

Paone, Tom. "The Most Fashionable Balloon of the Civil War." Smithsonian National Air and Space Museum, November 5, 2013.

Pierce, Paul. *Springer Ghost Book: A Theatre Haunting in the Deep South*. Columbus, GA: Pierce, 2003.

Ragan, Mark K. *Submarine Warfare in the Civil War*. Cambridge, MA: Da Capo Press, 2009.

Rosales, Albert S., comp. The Humanoid Contact Database. http://www.iraap.org/rosales.

Salter, Charles. "There's No Place Like an Antebellum Home for a Ghost." *Atlanta Journal-Constitution*, December 10, 1978.

Savannah Morning News. August 1, 1885.

————. December 12, 1897.

————. December 20, 1895.

————. December 20, 1893.

————. January 5, 1893.

————. July 16, 1885.

————. July 12, 1877.

————. March 1, 1891.

————. May 16, 1878.

————. September 3, 1886.

Serveny, Randy. *Freaks of the Storm, from Flying Cows to Stealing Thunder: The World's Strangest True Weather Stories.* New York: Basic Books, 2006.

Skinner, Charles S. *American Myths and Legends.* Philadelphia: J.B. Lippincott Company, 1903.

Smith, Burns Gordon, and Anna Habersham Smith. *Ghost Dances and Shadow Pantomimes.* Milledgeville, GA: Boyd Publishing, 2004.

Solomon, Brent. "Investigators Spot at Least One Ghost." WALB News, August 16, 2006.

———. "Windsor Hotel May Be Haunted." WALB News, August 11, 2006.

———. "The Windsor Is a Certified Haunted Hotel." WALB News, September 23, 2006.

Stricker, Lon. "Witness: The North Georgia Mothman." Phantoms & Monsters. http://www.phantomsandmonsters.com/2011/07/witness-north-georgia-mothman.html.

Strickland, Binky. "Terrorizing Tales." *Union-Recorder*, October 26, 1990.

Swancer, Brett. "Mysterious Vanishings with Bizarre Phone Calls, June 6, 2017." mysteriousuniverse.com.

Sylvania Telephone. February 7, 1895.

Techter, David. "A Flap of Glowing Crosses." *Fate* (June 1972).

Thomaston Times. October 25, 1973.

Thornton, Richard. "The Nodoroc: Gateway to Hell and Lair of the Wog." People of One Fire, March 21, 2013. https://peopleofonefire.com/nodoroc.html.

Toccoa Record. June 13, 2009.

WALB News. "Do You Believe in Ghosts?" October 31, 2014.

Walton County Vidette. February 18, 1873.

Waycross Journal-Herald. January 23, 1984.

Whitcomb, Jonathon D. *Live Pterosaurs in America.* N.p.: CreateSpace Independent Publishing Platform, 2011.

Wilkes, Donald E., Jr. "Senator Richard Russell and the Great American Mystery." *Flagpole* (November 2003).

Williams, Mark, ed. "Ramblings with Kelly." *LAMAR Institute Publication 7* (1990).

Wilson, Gustavus James Nash. *The Early History of Jackson County, Georgia.* Atlanta, GA: Foote and Davies Company, 1914.

ABOUT THE AUTHOR

*J*im Miles is the author of seven books of the Civil War Explorer Series (*Fields of Glory*, *To the Sea*, *Piercing the Heartland*, *Paths to Victory*, *A River Unvexed*, *Forged in Fire* and *The Storm Tide*) and *Civil War Sites in Georgia*. Five books were featured by the History Book Club, and he has been historical adviser to several History Channel shows. He has written two different books titled *Weird Georgia* and seven books about Georgia ghosts: *Civil War Ghosts of North Georgia*, *Civil War Ghosts of Atlanta*, *Civil War Ghosts of Central Georgia and Savannah*, *Haunted North Georgia*, *Haunted Central Georgia*, *Haunted South Georgia* and *Mysteries of Georgia's Military Bases: Ghosts, UFOs, and Bigfoot*. He has a bachelor's degree in history and a master of education degree from Georgia Southwestern State University in Americus. He taught high school American history for thirty-one years. Over a span of forty years, Jim has logged tens of thousands of miles exploring every nook and cranny in Georgia, as well as Civil War sites throughout the country. He lives in Warner Robins, Georgia, with his wife, Earline.